LEGENDARY LOCALS

of

LAS CR

NEW MEXICO

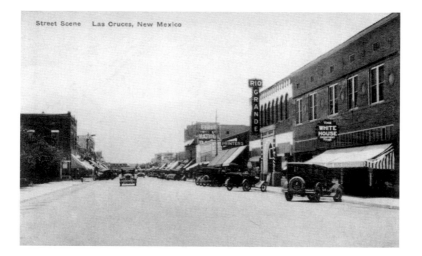

Street Scene Las Cruces, New Mexico

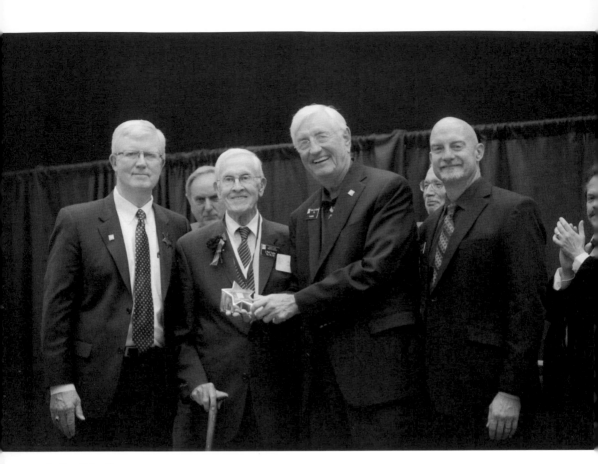

J. Paul Taylor
Pictured from left to right are New Mexico State University dean of the College of Education Michael Morehead, the Honorable J. Paul Taylor, NMSU president Garrey Carruthers, and NMSU Alumni Association Executive Council president Lee Golden. Taylor received the 2013 James F. Cole Memorial Award for Service. (Photograph by Adrianne Riley; courtesy NMSU Alumni Association.)

Page 1: Downtown
This downtown street scene of Las Cruces shows the Rio Grande Theatre, a prominent building still standing and used by the Doña Ana Arts Council. (Courtesy Rio Grande Theatre.)

LEGENDARY LOCALS

OF

LAS CRUCES
NEW MEXICO

CHARLOTTE TALLMAN

Copyright © 2014 by Charlotte Tallman
ISBN 978-1-4671-0133-2

Legendary Locals is an imprint of Arcadia Publishing
Charleston, South Carolina

Printed in the United States of America

Library of Congress Control Number: 2013948329

For all general information, please contact Arcadia Publishing:
Telephone 843-853-2070
Fax 843-853-0044
E-mail sales@arcadiapublishing.com
For customer service and orders:
Toll-Free 1-888-313-2665

Visit us on the Internet at www.arcadiapublishing.com

Dedication
To the men and women on the pages of this book who lost their lives, but left their legacy.

On the Front Cover: Clockwise from top left:
Las Cruces Tennis Team, a recreational look at some of the city's founding members (courtesy NMSU Library, Archives and Special Collections (LASC), page 40); Leonard Jimenez, philanthropist (courtesy Wendy Ewing, page 103); Marci Dickerson, entrepreneur (courtesy Marci Dickerson, page 106); Susana Martinez, New Mexico governor (courtesy Office of the Governor, page 63); Letticia Martinez, blind Paralympics swimmer (courtesy Steve Martinez, page 104); Theodore Roosevelt with R.L. Young, United States president and Las Cruces mayor (courtesy NMSU LASC, page 34); John Sutter, youngest New Mexico paramedic (courtesy Stephanie Mothena Sutter, page 23); Heath Haussamen and Trip Jennings, creators of New Mexico In Depth (courtesy Heath Haussamen, page 108); Bob Diven, Las Cruces Farmer's Market chalk artist (courtesy Lincoln Michaud, page 16).

On the Back Cover: From left to right:
Dr. Nathan Boyd and family, creator of Boyd's Sanitarium (courtesy NMSU LASC, page 29); John Hummer, first CEO of area's second hospital (courtesy John Hummer, page 66).

CONTENTS

ACKNOWLEDGMENTS

I am grateful, first and foremost, for each person who allowed me to share their story in this book.

Many thanks go to the photographers for allowing me to share their talent. Russell Bamert, Bill Faulkner, and Melissa Schumer: I know it was not easy to meet my every request, but you did it graciously. I am honored to call you all colleagues and humbled to be considered your friend. Lincoln Michaud, your availability and willingness to share your work is something I will never forget.

Thank you to the *Las Cruces Sun-News* and Frances Silva, Morgan Switzer McGinley at *Las Cruces* magazine, and Kelly Jameson at the Doña Ana County Sheriff's Department.

To my mom, Reva Higgins, you are a talented woman and writer. Thank you for your support, and more importantly, your help when I needed it the most.

Stephanie Sutter, you have my infinite gratitude for reaching deep into your heart and finding the courage to remember John during this project.

Many thanks to Stephanie Armitage and Ernie Sichler for your efforts tracking down photographs.

I want to thank NMSU and the various departments that helped me, including Dean Wilkey, reprographics manager at NMSU and the Library and Special Collections (NMSU LASC). A big Aggie shout-out and thank you to Tammie Campos, executive director for NMSU Alumni Relations, and all of the NMSU Alumni Association staff.

Finally to my dad, who fed my love for history by always telling me about the past; my Momo, who taught me the value of community; the Schumers for always making life exciting, especially Landon and Jordan; Gretchen for showing me how much appreciation this community, and especially the Organ Mountains, deserves; and Lexy, for always believing I could do this . . . I love you more.

INTRODUCTION

Writing a book is no small task, but even harder than fitting words on paper to adequately describe the most amazing people in my community is knowing that there is not a book big enough in the world to highlight all the legendary locals who have made a difference in Las Cruces and the surrounding areas. That humbling realization inspired me. It also made me cherish my community home even more.

When I was the editor for *Ventanas* magazine, I had a lot of favorite stories surrounding the people and places of the Mesilla Valley. Even more plentiful than these stories were my favorite times. Most of those times included photo shoots with my dear friend Russell Bamert, a renowned photographer who has his work forever immortalized in national, state, and regional publications.

When Russell and I had a photo shoot scheduled, I would make sure to clear my schedule for the four hours after the shoot. I needed that time to take in all that Russell had to share. Russell spent his whole life in the area. He still lives in the home he grew up in, on the land his dad worked, with antiques his mother collected. Russell watched newcomers come and old timers pass, and remembered their stories.

There are many people in this book, like Russell, who have affected me on such a personal level, it was truly touching to revisit their lives once again. One man in particular, Sam Lopez, was a friend for such a short time, but will remain forever in my heart. He was a World War II veteran who spent the last months of his life yearning to see the National World War II Memorial in Washington, DC. Sadly, he died shortly before he could make the trip, but he did not die without leaving a legacy in Las Cruces and the surrounding areas.

Reconnecting with, and revisiting the lives of, old friends was not the only highlight while working on this book. I also had the unique opportunity to build new relationships and experience the kindness behind locals who want to help. Photographer Lincoln Michaud is one of those locals. He heard I wanted to highlight the Las Cruces Farmer's Market, so he offered everything he could to get them the recognition he thought they deserved. Then when I exhausted all his resources for the Farmer's Market, he provided anything else I needed as well. Lincoln is one of thousands of kind spirits who make Las Cruces what it is.

Donna Tate, a woman I have admired for some time, said recently that this is a community that knows how to care for people. She is right. This is also a community that knows how to expand their knowledge, leave a mark for generations to come, and embrace those in need. It has been that way for decades.

In 1869, Agostini-Justiniani, or the Hermit, made his home in La Cueva, a natural shelter in the Organ Mountains. The Hermit was a praying man, and people would often bring the sick and lame to him for healing. Around the same area, Dr. Nathan Boyd, a renowned medical doctor and international businessman, converted the Van Patton Mountain Camp into a tuberculosis treatment center.

Era Rentfrow had a heart for the community, especially those who were taken from it too soon. She devoted her life to keeping the memory of fallen Aggies alive. Her dedication, and the memory of 126 Aggies killed in World War II, is the motivation behind the Aggie Memorial Tower and each of their photographs that cover the walls. Now, more than 100 years later, Ben Woods, chief of staff and the senior vice president for external relations at NMSU, keeps her memorial going.

The Honorable J. Paul Taylor has done nearly everything short of moving mountains for the people of Las Cruces and the state of New Mexico, but his humbleness matches his dedication. He is known to respond to accolades and awards with a thank you, followed promptly by a statement saying there are so many others who deserve the award more than he. There are others who deserve awards, not more than J. Paul, but equally so.

There is Olga Granado who spent her entire life serving others. The only trouble she ever got in was spending money on others that she did not have. Gina Orona-Ruiz spent her career doing what she could to comfort those affected by domestic violence, and Donna Richmond will forever be a victim advocate. Barbara Funkhouser still lives on the land she grew up on, tending to the vines of the first grapes brought to Las Cruces used for wine. As the first editor at the *El Paso Times*, she drove back and forth between El Paso each day for work, munching on those grapes. As the founding board member of the New Mexico Farm & Ranch Heritage Museum, she is committed to the history of the area and to community.

Like those who have lived some time of their life in Las Cruces, there are those who are just getting started with the impact they will have, like blind Paralympic swimmer Letticia Martinez and journalist Heath Haussamen, showing that in Las Cruces there is an infinite circle of people leaving a history and changing the course of the future.

Those mentioned above, and the others throughout this book, are just a few of the many people who have made Las Cruces what it is by their name, through their work, or with their legacy. They are mothers, fathers, daughters, son, brothers, and sisters. But more than anything, in the author's eyes, they are legendary locals.

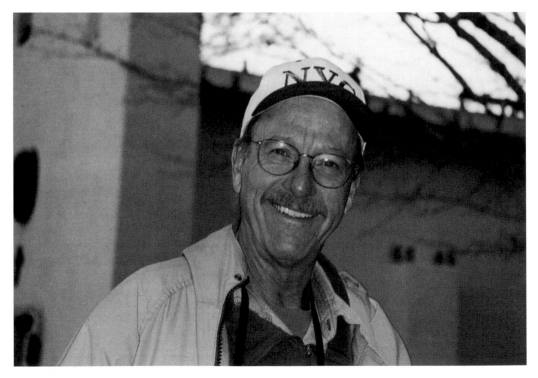

Russell Bamert
Bamert made a name for himself as a photographer, immortalizing southern New Mexico with his photographs for various national and regional publications, including *New Mexico Magazine*. (Courtesy Russell Bamert.)

CHAPTER ONE

What Makes
Las Cruces Las Cruces

The City of the Crosses has a lot of backbone keeping it together. There are artists, entrepreneurs, scientists, engineers, writers, actors, agriculturists, professors, governors, founders, and researchers all calling the area home at one point or another. The wide variety of inhabitants can be credited to the vast and vibrant culture and land that surrounds Las Cruces.

As the county seat of Doña Ana County, Las Cruces, established in 1849, is the second largest city in the state and the heart of the Mesilla Valley—the agricultural region on the flood plain of the Rio Grande extended from Hatch, New Mexico, to the west side of El Paso, Texas.

During the heyday of the Wild West, dangers were not far from anyone, especially around Las Cruces. Open land and deep mines around the state were the reward for an empty pocket and greedy disposition—if those searching made it through the day without a bullet in the back of the head or a noose around the neck. They were the days when thousands of pioneers moved westward in search of land, gold, and silver bringing seemingly instant towns vibrant with populations of drinkers, miners, painted ladies, and the occasional family. As quick as many of the towns filled up, they emptied, but some people settled in the area for a future made possible by the men and women who believed in survival, persistence, and the birth of the area called Las Cruces.

Beyond the threat of cowboys and Indians, and because of the fertile land, Las Cruces is home to New Mexico State University, New Mexico's only land grant university. NMSU was founded as an agricultural school in 1888 under the name Las Cruces College by Hiram Hadly, a respected educator from Indiana. A year later, the territorial assembly of New Mexico provided for the establishment of an agricultural college and agricultural experiment station. Designated as the land grant college for New Mexico under the Morrill Act, it was named the New Mexico College of Agriculture & Mechanic Arts. Las Cruces College then merged with the New Mexico College of Agriculture & Mechanic Arts and opened on January 21, 1890. It began with 35 students and 6 faculty members. It received its present name, New Mexico State University, in 1960. The university offers a wide range of programs and bachelor's, master's, and doctoral degrees through its main campus and four community colleges.

Because of the surrounding desert and wide-open lands, White Sands Test Facility and White Sands Missile Range are right at home in the area. WSMR is a United States Army range providing the Army, Navy, Air Force, Department of Defense, and other customers with high quality services for experimentation, testing, research, assessments, development, and training. The range was established in 1945 and covers approximately 2.2 million acres, and the historical implications are not just governmental. Early on during the establishment of the range, ranch families gave up their land either willingly or by compulsion, and aged buildings that once housed ranchers can still be seen across the land. WSMR is bordered by Fort Bliss to the south and by Holloman Air Force Base to the west.

The opportunities at WSMR and NMSU are not the only reason people come to the area. The year-round great weather attracts many out-of-towners to visit, and often stay, and a welcoming community encourages others to grow their talents and businesses. There are galleries, golf courses, plazas, wineries, restaurants, parks, and breweries that leave a little something for everyone.

It is no wonder Las Cruces continues to hit the national news for anything from its thriving farmer's market to its hometown district attorney becoming the first Latina governor. In 2012, AARP named

it one of the top 10 sunny places to retire, *PARADE Magazine* said it was one of the top 25 hardest working towns in America, and *Guidebook America* said it was one of the country's top 10 spring break destinations for families. In 2010, *Sunset* magazine named it one of the 20 best towns of the future.

From the beauty of the Organ Mountains to the valley containing the winding Rio Grande River, Las Cruces is a town of splendor and brilliant people.

The past, present, and future of Las Cruces perfectly blend together to make it what it is: a City of Crosses, a city of opportunity, and a city of legends.

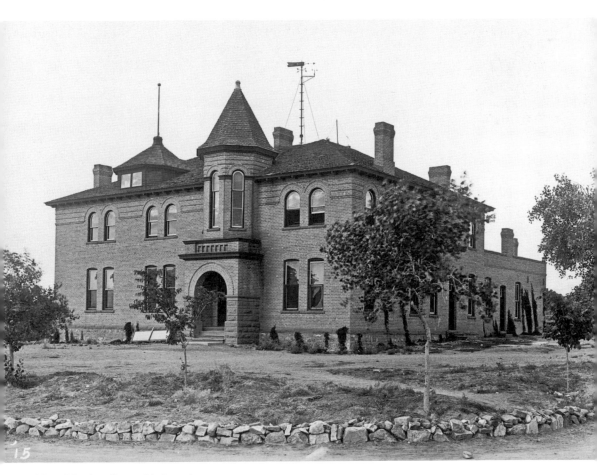

New Mexico State University
Tradition is everywhere at NMSU. As the university celebrated 125 years in 2013, it was the perfect time to remember the rich history of the campus. New Mexico was still a territory when Las Cruces College, led by Hiram Hadley, opened the doors of its two-room building in the fall of 1888. One year later, the New Mexico territorial legislature authorized the creation of the New Mexico College of Agriculture & Mechanic Arts, an agricultural college and experiment station. Las Cruces College merged with New Mexico College of Agriculture & Mechanic Arts on January 21, 1890, to have 35 students and 6 faculty members. The university found its third and final name in 1960 when it became NMSU. Pictured here is NMSU's first science hall. (Courtesy NMSU LASC.)

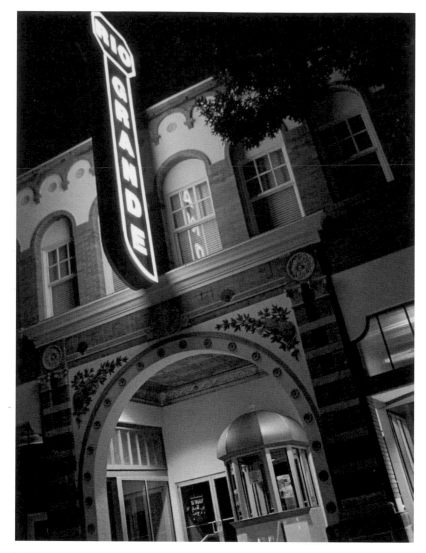

Rio Grande Theatre

In the 1920s, the Rio Grande Theatre was a regal building, welcoming theatergoers to events of film, fun, and fancy. With just 30¢ and a couple hours of time, it was easy to be transported into a world of whimsy and exhilaration, and it was not just what was on the screen that wowed the audience.

The theater was built by C.T. Seale and B.G. Dyne in 1926 and remained under the ownership of the Seale and Dyne families until Jan Clute and Carolyn Muggenburg, granddaughters of C.T., gifted their portion of the theater to the Doña Ana Arts Council in 1998; later that year, DAAC became sole owner of the property. Southwest architect Otto Thorman created the look of the Rio Grande Theatre in the Italian Renaissance Revival style popular in the 1920s and 1930s with murals that covered the walls and entryways and second-story arched windows encased with golden bas-relief violins, horns, and foliage. The outside of the theater contains some of the original décor.

The interior was designed in a Spanish baroque style and included white velour wall tapestries with red velvet festoons depicting historical figures. Large drapes of turquoise velvet with a gold plush valance and gold satin appliqué complemented the designs on the exterior. It is a perfect setting for Peter Pan. (Above, courtesy David Salcido; opposite page, both courtesy Rio Grande Theatre.)

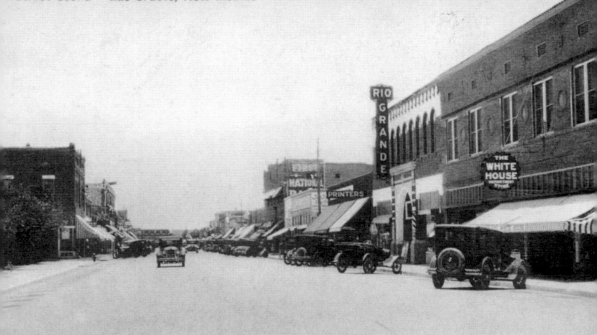

Street Scene Las Cruces, New Mexico

Doña Ana County 4-H Club
The 4-H Club was created as an agriculturally focused organization around 1902 to help youth reach their full potential. Today, 4-H focuses on citizenship, healthy living, science, engineering, and technology programs. Bob Porter (standing third from left) poses with his Doña Ana County 4-H Club in 1940. (Courtesy Bob Porter.)

Find more books like this at
www.legendarylocals.com

Discover more local and regional history books at
www.arcadiapublishing.com

INDEX

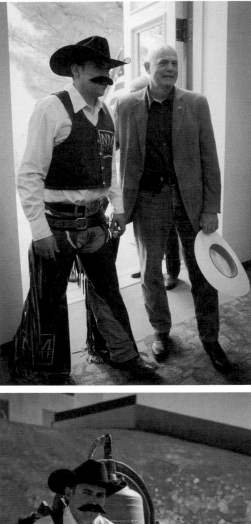

Pistol Pete

It is not uncommon to see a pistol-toting mascot on the NMSU campus, and while the gun is a fake, the spirit is genuine. In the 1950s, Pistol Pete became the mascot for NMSU, but the mascot has been around a lot longer than that. Frank "Pistol Pete" Eaton began sharpshooter training with soldiers, where he earned his nickname at the age of 15, and he used that training to gun down his father's killers and avenge his death. In 1923, Eaton agreed for his photograph to be turned into a college caricature. Pictured is Pistol Pete with NMSU provost Dan Howard. (Courtesy NMSU Alumni Association.)

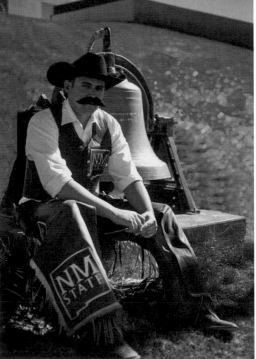

Busy Mascot

The person inside the NMSU mascot, played by students who receive scholarships from the NMSU Alumni Association, makes around 100 appearances a year. The job is usually split between two different students, like Conlan Burk. (Photograph by Adrianne Riley; courtesy NMSU Alumni Association.)

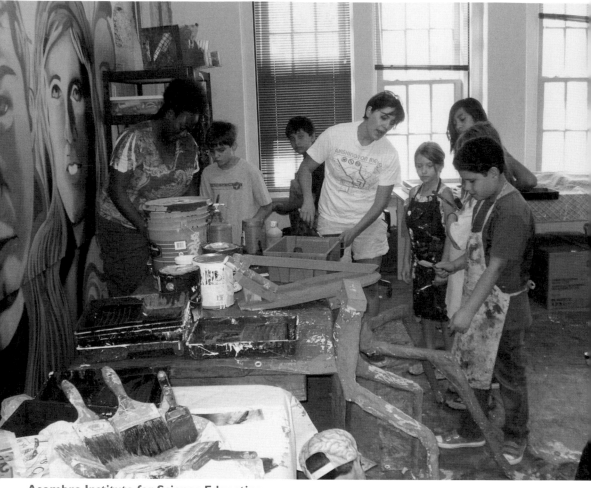

Asombro Institute for Science Education
The Asombro Institute for Science Education is a nonprofit organization led by executive director Stephanie Bestelmeyer. The organization is dedicated to increasing scientific literacy by fostering an understanding of the Chihuahuan Desert. The program serves more than 17,000 students and 1,500 adults in New Mexico and west Texas with inquiry-based science education programs each year. (Courtesy Community Foundation of Southern New Mexico.)

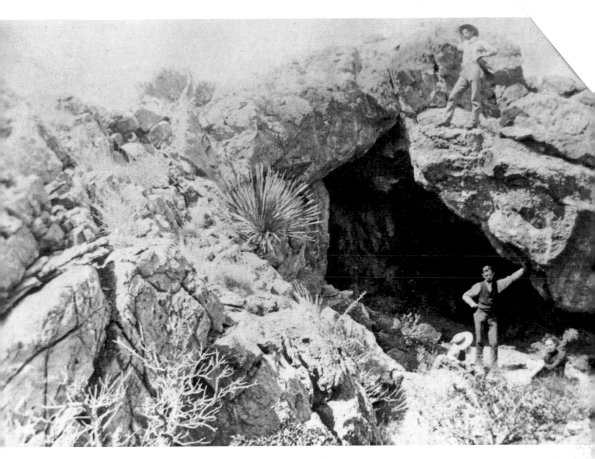

Organ Mountains
The ruggedness of the Organ Mountains attracts a lot of remarkable attention when the eye turns east from the city of Las Cruces. Trails maintained by the Bureau of Land Management offer solitude and a look into what once was. Hermits, those suffering from tuberculosis, and wild gunmen once walked the land. Now, hikers can experience The Needles, Baylor Pass, and La Cueva (pictured). (Courtesy NMSU LASC.)

Las Cruces Farmer's & Crafts Market
In the summer of 1971, the Las Cruces Farmer's & Crafts Market began with local farmers gathering to sell their locally grown produce. The market is one of the biggest attractions in Main Street downtown and provides shoppers access to locally grown agricultural products and locally crafted handmade items.

Bob Diven creates a chalk masterpiece many Saturdays at the farmers market. (Both, courtesy Lincoln Michaud.)

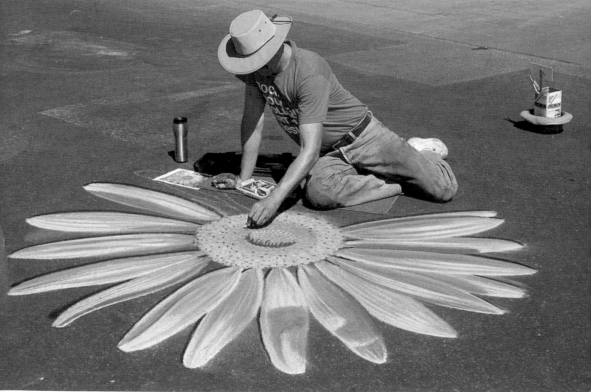

CHAPTER TWO

Too Many Tears

Like the river that flows through the valley, there have been many tears shed in Las Cruces. But despite the tears, the community has remained strong, offering a shelter for the hurting and a strong will to make things right.

The Hermit of La Cueva was one of the first unsolved mysteries of the area. He was a praying man, and a trusting man. He found a home in the natural rock of La Cueva, surely sitting at the base of the monstrous rock viewing the town below him. Many times he would get on his knees with his rosary in hand and extend his prayers. As in life, in death he clung to the rosary. His murder was never solved, but his name has never been forgotten.

The murder of Ovida "Cricket" Coogler is another mystery that consumes the town, prompting books and movies to forever remember the feisty, yet naïve Coogler. She disappeared while spending time with visiting politicos. The last time she was seen alive, she was stepping into a state car. Several weeks later, rabbit hunters found her body. Hers was a death that brought on accusations of scandal and coercion, but despite the goodwill of some who really did want to see her murder solved, there were others with more clout who got in the way.

Perhaps the greatest unsolved mystery of the area is the Las Cruces Bowling Alley massacre. On Saturday, February 10, 1990, two men walked into Las Cruces Bowl shortly before 9:00 a.m. and shot seven people, execution-style. Amy Houser, Steven Teran, Paula Teran, and Valerie Teran died. Three others, Stephanie Senac, Ida Holguin, and Melissa Repass were wounded. The identities of the gunmen have never been determined. Twenty-three years later, the motives for the cold-blooded killings remain unknown and the murder case remains unsolved, despite the network television program *America's Most Wanted* broadcasting a segment on the bowling alley massacre in 2010.

Even one unsolved murder case is one too many. One murder is one too many. But, when a murder does happen and laws change because of it, the outcome shows the true sense of community outcry.

In the case of Brianna Lopez, a baby beaten so badly she is known to have suffered one of the most brutal child-abuse cases in state history, her death prompted a major change in New Mexico law. Baby Brianna, as she is affectionately known throughout the area, died at six months of age in 2002 after being beaten and raped by family members. Gov. Susana Martinez, who was the district attorney at the time, won convictions and maximum sentences for the three abusers, but the trial highlighted shortcomings in the law. When Baby Brianna was killed, a person who committed intentional child abuse resulting in death faced a maximum of 18 years in prison. Her case brought on a major change with the help of people like state senator Mary Jane Garcia of Doña Ana. After three years, Garcia eventually helped change the law to make the crime punishable by a life sentence.

Katie Sepich is another name that brings sadness so deep it can cause community members to shake their fist and wonder why, yet it is a powerful example of those determined to find some sort of revolution for a senseless tragedy. Sepich was walking home one night after hanging out with friends when she was dragged away, found later by target shooters partially clothed and burned at an abandoned city dumpsite. She was 22 years old. In the aftermath of that horrific experience, her parents, Dave and Jayann, became advocates. The Sepich family has worked tirelessly to see legislation passed in all 50 states to mandate taking DNA samples upon felony arrest, and Katie's Law was passed in New Mexico

in 2006. To date, 27 states have passed legislation, and Congress passed The Katie Sepich Enhanced DNA Collection Act of 2012, which authorizes federal funding to help states implement arrestee DNA programs. As a result, thousands of cold case crimes have been solved, crimes have been prevented, and lives have been saved.

In December 2006, Gabrial Avila gave a DNA sample as a result of a burglary conviction. That sample matched the DNA found on Katie's body. He was convicted of her rape and murder and sentenced in May 2007 to 69 years without possibility of parole. Gabrial Avila had been arrested for felony burglary just three months after Katie's murder. Had Katie's Law been in effect, his DNA would have been collected then and her killer would have been identified three full years sooner.

Keeping the memory of those who passed too soon alive is at the heart of the memorials Las Crucens hold, and those they set up. The Aggie Memorial Tower at NMSU honors 126 Aggies killed in World War II, and viewing the photographs that line the wall is a humbling experience—an experience that continually unites the community.

Another community that embraces its own is the first responders, as well as the friends and family of John Sutter. Sutter was happily expecting his first child with wife Stephanie when he was killed tragically in a helicopter crash during a routine training exercise. When Ryan was born, Stephanie was faced with an intense identity change. She went from loving wife and expectant mother to a widowed single mom. She herself is a hero, and her desire to keep the memory of John alive is as strong as ever three years later.

There is no doubt there have been too many tears in Las Cruces—for those in this book and the many others who have unknowingly taken their last breath during a tragic moment. Whether their name is said aloud, or in print, Las Cruces keeps their memories alive. To this city, they are the true legendary locals.

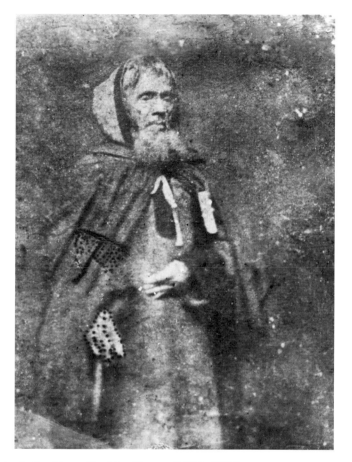

Agostini-Justiniani, the Hermit of La Cueva (1800–1869)

In 1869, La Cueva, a natural shelter in the Organ Mountains, was home to a man by the name of Agostini-Justiniani, the Hermit.

He was born in 1800 to a noble Italian family. When he was young he studied to be a priest, but when it came time for him to take his vows, he refused for some unknown reason. He spent his time in prayer while traveling, mostly by foot, through Europe, Mexico, South America, Cuba, and the United States.

Seven years before his death, he walked the wagon train of Eugene Romero from Kansas to Las Vegas, New Mexico, and lived for a while in Romeroville before settling on Cerro Tecolote, northwest of Las Vegas. The hill has since become known as Hermit's Peak.

In 1869, Agostini decided to put his roots down. He spent time on the Old Mesilla Plaza visiting the Barela family, and told them of his plan to live at La Cueva. The Barela family, and others, were concerned about his safety and warned him of the dangers of living out there alone. He responded to their concerns by saying, "I shall make a fire in front of my cave every Friday evening while I shall be alive. If the fire fails to appear, it will be because I have been killed."

One of the many people believing in the miraculous healing powers of the Hermit was Antonio Garcia, who transported sick people up to La Cueva for healing. One Friday night in the spring of 1869, the fire failed to appear and Antonio Garcia led a group of people up the mountain. They found the Hermit lying face down on his crucifix with a knife in his back. He was wearing his penitential metal girdle full of spikes.

Agostini is buried in the Mesilla Cemetery. His headstone reads, in Spanish: "John Mary Justiniani, Hermit of the Old and New World." The Hermit's murder was one of many unsolved murders in the late 1800s in Doña Ana County. (Courtesy NMSU LASC.)

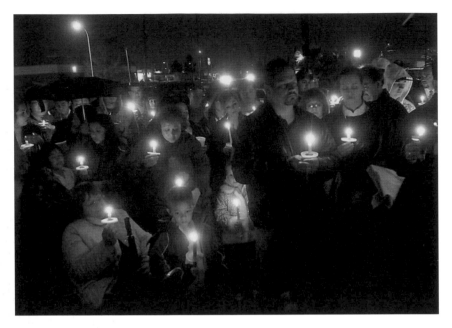

Las Cruces Bowling Alley Massacre

February 10, 1990, was a dark day for the city of Las Cruces. Two unknown men walked into Las Cruces Bowl and shot seven people. Four of the seven victims died, including Amy Houser, Steven Teran, Paula Teran, and Valerie Teran. Melissa Repass, then 12, was shot five times but her will to live won over and she called the police informing them of the attack. Two others, Stephanie Senac and Ida Holguin, were also wounded. The case remains unsolved, and police continue to pursue leads that could lead to the capture and arrest of the two men involved in the killings while the community often remembers through candlelight vigils. Robert DiMatteo, who was the first to enter the bowling alley, described what he saw that day in February 1990. The Las Cruces resident was interviewed and filmed at the Las Cruces Police Department for a documentary about the unsolved murders. (Both photographs by Norm Dettlaff, courtesy *Las Cruces Sun-News*.)

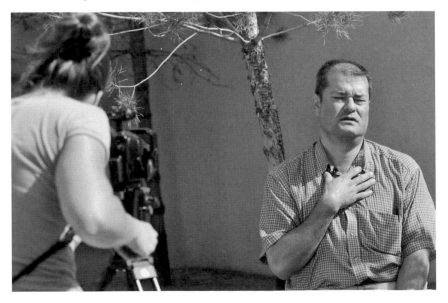

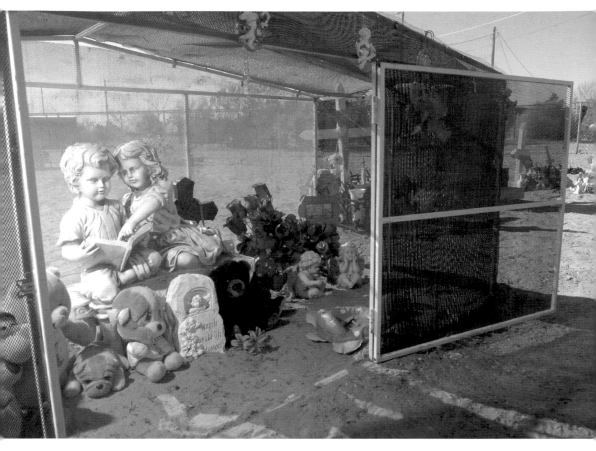

Baby Brianna Lopez (2/2002–7/2002)
When Brianna Lopez died as a result of violent and tortuous child abuse at the age of six months in 2002, her death sparked a community revelation and major change in New Mexico law. Former district attorney Susana Martinez, who is now the New Mexico governor, prosecuted the case with passion. She highlighted shortcomings in the child abuse law, particularly that when a person was convicted of intentional child abuse resulting in death, they only faced a maximum of 18 years in prison. With the help of state senator Mary Jane Garcia of Doña Ana, the law eventually changed to make the crime punishable by a life sentence. When Baby Brianna died, no photos of her living were found. Baby Brianna's grave, which was caged in by the family, shows stuffed animals and toys left on February 10, 2012. Though the tears continue to fall for this smallest of victims, Baby Brianna's name will never be forgotten. (Photograph by Robin Zielinski, courtesy *Las Cruces Sun-News*.)

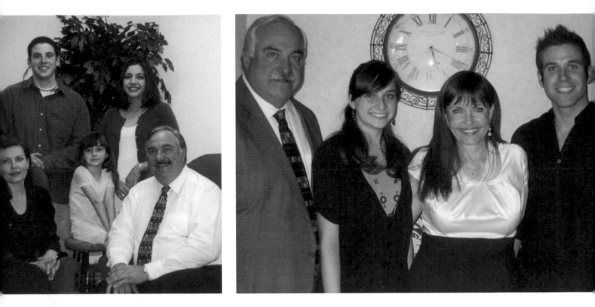

Katie Sepich (1980–2003)

Sepich was so spirited and energetic she earned the nickname "Kamikaze Katie" early on, and that nickname stuck with her as she positively impacted many of those around her. On Saturday, August 30, 2003, after spending an evening with friends, she began walking the six blocks to her home. She never made it. The next morning her partially clothed, burned body was found by target shooters at an abandoned city dumpsite. She was 22 years old. Over 1,000 people attended her funeral at St. Edward's Church in Carlsbad, New Mexico.

In the aftermath of that horrific experience, her parents, Dave and Jayann, became advocates. The Sepich family has worked tirelessly to see legislation passed in all 50 states to mandate taking DNA upon felony arrest. Katie's Law passed in New Mexico in 2006. To date, 27 states have passed legislation, and Congress passed The Katie Sepich Enhanced DNA Collection Act of 2012, which authorizes federal funding to help states implement arrestee DNA programs. As a result, thousands of cold-case crimes have been solved, crimes have been prevented, and lives have been saved.

At left, Katie, standing on the right, poses with her family in 2000. At right, Dave, Caraline, Jayann, and AJ Sepich are pictured in a family photograph. (Both, courtesy Jayann Sepich.)

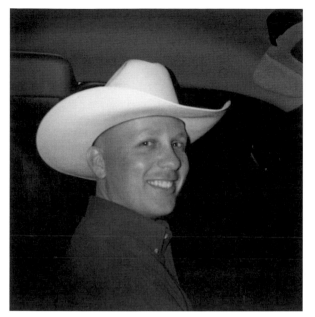

John Sutter (1975–2010)

At the age of 19, Sutter became the youngest paramedic in New Mexico, often affectionately referred to as "Baby Doc" because of his age. He never let anything like age stop him, and he took his profession seriously, receiving a CCEMT-P, the highest certification for a paramedic. He also taught up-and-coming EMS professionals and was an active volunteer fire captain and reserve police officer. While his career was important, Sutter's family meant even more. He was happily expecting a son with wife Stephanie Mothena Sutter when he died in a helicopter crash along with pilot William Montgomery and paramedic Anthony Archuleta while on a two-day training mission at Fort Bliss just outside El Paso, Texas.

Sutter left behind many family and friends, but no void stronger than the one left within his unborn son, Ryan, pictured at age three, who is known to ask his mother if Daddy John can come down from heaven just for a bit. As a strong single mother, Stephanie devotes her life to raising a son John would be proud of while keeping his memory alive. (Top left and bottom right, photographs courtesy Stephanie Mothena Sutter; top right, photograph by Melissa Schumer.)

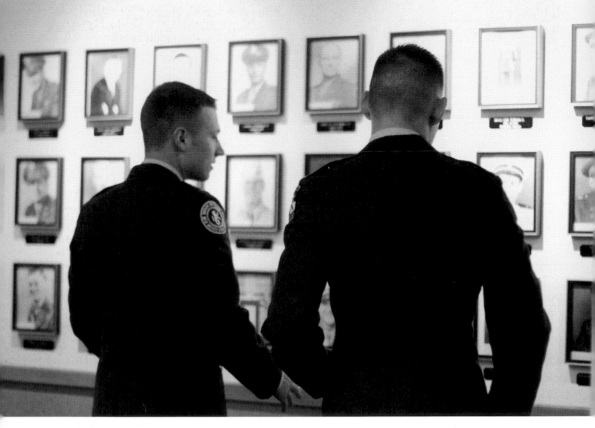

NMSU Aggie Memorial Tower
Nearly 100 years ago, Era Rentfrow stepped on the campus of New Mexico A&M as one of 23 entering freshmen. That step brought her closer to the love of her life, and the impact she had on the university as a whole—an impact that is remembered even today. Rentfrow was engaged to early Aggie footballer Joe Quesenberry, but she would never become his wife. After he was called to duty, Quesenberry became the first New Mexico Aggie killed in combat in World War I. Rentfrow never married, and after graduating from New Mexico A&M, she devoted her life to keeping the memory of fallen Aggies alive. Her dedication, and the memory of 126 Aggies killed in World War II, is the motivation behind the Aggie Memorial Tower and each of their photographs that cover the walls. (Courtesy NMSU Alumni Association.)

CHAPTER THREE

Shaping the Mesilla Valley

There are so many people who changed the face of the Mesilla Valley. Some have been remembered throughout the years, like Billy the Kid and Pat Garrett. Others had their hand in incredible movements but never stayed long in the spotlight.

Hiram Hadley had a hand in one of the greatest achievements of the area, NMSU. After arriving in New Mexico in 1887, Hadley worked with local legends like John R. McFie, Samuel Steel, and Albert J. Fountain to increase the educational facilities in the area. He became the founder and first president of Las Cruces College in 1888, which eventually became the New Mexico College of Agriculture & Mechanic Arts, and later New Mexico State University. Hadley served in those roles until 1894, returning to the campus later as a professor and regent. His impact was great even back then, meeting with others in an old adobe building downtown. Now, the campus he founded is a comprehensive land grant institution of higher learning, a NASA space grant college, a Hispanic-serving institution, and home to the very first honors college in New Mexico. Hadley created an opportunity for hundreds of thousands of students to obtain an advanced education.

Clara Belle Williams is one of those people who relished that opportunity. She was born in Plum, Texas, in October 1885 as Clara Belle Drisdale. Education was extremely important to her. She attended Prairie View Normal and Independent College (now Prairie View A&M University) in 1903, and was valedictorian of her 1908 graduating class. In 1917, she married Jasper Williams and the couple had three sons, Jasper, James, and Charles. In 1928, Williams enrolled at New Mexico College of Agriculture & Mechanic Arts, taking courses in the summer as she taught at the segregated Booker T. Washington School for more than 20 years. Her persistence paid off, and in 1937 she became the first black graduate from the university, receiving her bachelor of arts degree in English. She was 51 years old. Williams continued her education by taking graduate level classes into the 1950s, becoming an inspiration to the community as a whole and her friends and family, particularly her three boys, who she urged to obtain a higher education. All three went to college and graduated with medical degrees, eventually becoming the founders of the Williams Clinic in Chicago. Williams was a quiet example of the persistence so many Las Crucens have.

Russell Armitage is another person who focused on education. In his case, he endeavored to learn how to read. Armitage lived with dyslexia for 32 years of his life, finding help with job applications when he could not read them himself. When he did find a job he wanted to excel in, he realized he would need to pass a test to get certified. He had to decide to quit or learn to read. He chose the latter. He began to meet with a reading tutor, and as his ability to read got stronger, so did his desire to help others. He started a support group to help others overcome illiteracy, and because of his work transforming the lives of others, he was selected to attend the National Adult Literacy Congress in Washington, DC, where he met first lady Barbara Bush. Fear did not stop him, and his compassion and fight against illiteracy changed the lives of many.

Armitage is just one of many who not only realized others needed help but stepped up to make a difference. Las Cruces is a community built on the compassion of others. Olga Granado is one of those builders. As a community advocate, there was very little Granado would not do to help someone. Even after a cancer diagnosis, Granado continued her work with Prison Family Services and the Hospitality

House at the Southern New Mexico Correctional Facility. At the end of her life she wanted one thing—to make sure the relationships between children of inmates and their parents were preserved.

The shaping of the Mesilla Valley, and the people within it, has happened because of trillions of moments and decisions made by people like Hadley, Williams, Armitage, and Granado.

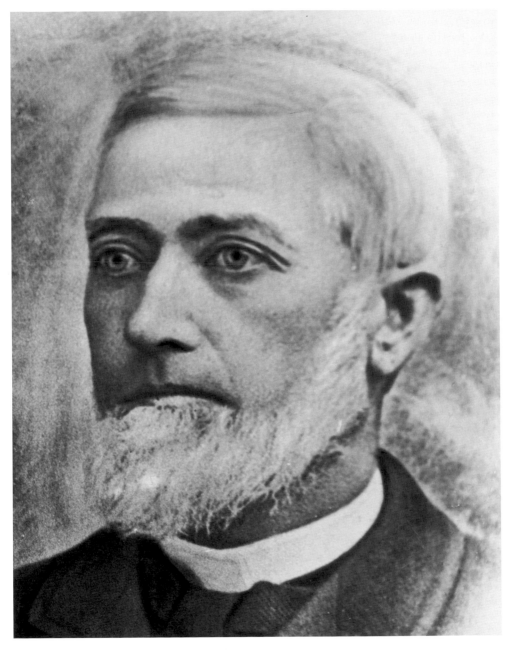

Hiram Hadley (1833–1922)
After arriving in New Mexico in 1887, Hadley was soon guided into a legacy that has remained strong throughout the decades. He became the founder and first president of Las Cruces College in 1888, which eventually became the New Mexico College of Agriculture & Mechanic Arts, and later New Mexico State University. Known as the father of education in the state, Hadley also started the first public school in southern New Mexico. At the time of his death, he was survived by his widow and two daughters, Anna Hadley of Mesilla Park and Caroline Allen of Chicago. Hadley's funeral was held in Hadley Hall, and the funeral procession to the grave was a mile in length. The body of President Hadley was placed to rest in the Masonic Cemetery at Las Cruces. (Courtesy NMSU LASC.)

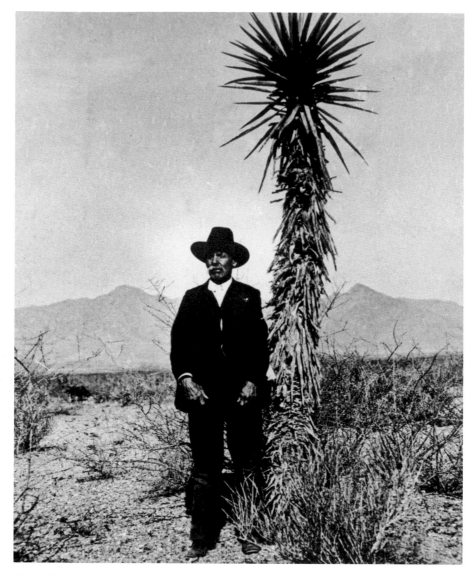

Col. Albert Eugene Van Patten (1839–1926)

Col. Albert Eugene Van Patten was a lot of things in his life, and while various stories of his successes and failures circulate, one theme remains—he was never afraid to try.

In his early 20s, Colonel Van Patten was a conductor on a stagecoach when it was ambushed by Apaches. While most of the coach's mules were killed, Van Patten, the driver, and six passengers were able to escape after a long standoff. His will to survive served him well when he joined the Confederates during the Civil War, and later when he served as county sheriff and deputy US marshal, leading the posse that tracked the murderers of Col. Albert Fountain and his son Henry.

Two of Colonel Van Patten's greatest achievements in the area include his involvement as cofounder of what is now New Mexico State University and serving as a consultant for Teddy Roosevelt concerning the formation of the Rough Riders of Spanish-American War fame.

Colonel Van Patten began construction of a remote resort nestled deep within the Organ Mountain range, but in the early 1900s he sold the Van Patten Mountain Camp to Dr. Nathan Boyd. (Courtesy NMSU LASC.)

Boyd's Sanitarium

Many who visit the remains of Boyd's Sanitarium consider it a modern-day ghost story, expressing a belief in the paranormal and visions of those who took their final breath in the tuberculosis sanitarium. The remains of Boyd's Sanitarium, beginning first as a mountain resort for Col. Eugene Van Patten, were constructed by Dr. Nathan Boyd, a renowned medical doctor and international businessman. Boyd purchased the facility and converted it to a tuberculosis treatment center with one patient in mind, his beloved wife. As tuberculosis became widespread, the sanitarium became filled to its limit. Hundreds of people eventually succumbed to the unforgiving disease. In the early 1900s, Dr. Boyd was involved in a court case that would eventually deplete his funds, and he sold the sanitarium to a Dr. T.C. Sexton from Las Cruces in the 1920s. It remained open as a sanitarium and resort for several more years until Boyd's son Earl bought the land and remained there until he left to serve in the military. Boyd's Sanitarium remained vacant and is now a tourist stop. (Courtesy NMSU LASC.)

Mariana Perez Fountain (1850–1915)
Mariana Fountain was married to Col. Albert Jennings Fountain, a Mesilla lawyer whose most famous client was Billy the Kid, and was also an assistant district attorney. After serving a term in the state legislature, he and his son Henry disappeared near White Sands on the way to their home in Mesilla, leaving a scene that showed a violent end. Their bodies were never found and no one was ever charged with their murder. (Courtesy Stephanie Johnson-Burick.)

Albert J. (1887–1971) and
Maria Chavez Fountain (1883–1972)
Albert was the first mayor of Mesilla, and Maria was the first postmistress of Mesilla. They are the great-grandparents of Stephanie Johnson-Burick. Johnson-Burick still lives in the family home in Mesilla—a family home since 1934. (Courtesy Stephanie Johnson-Burick.)

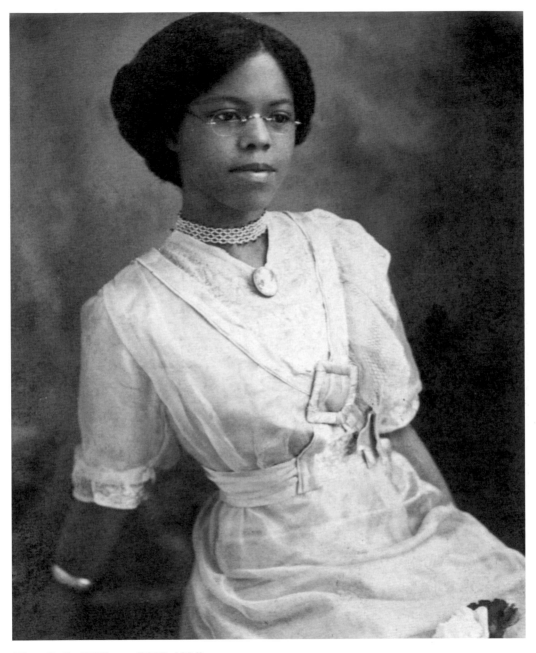

Clara Belle Williams (1885–1994)
Williams was the first African American woman to graduate from NMSU, and her accomplishment showed her persistence and drive. She did not allow segregation to get in the way of fulfilling her desire to complete college and become a teacher. Williams made education her priority and she is a prime example of someone who did not let obstacles dictate her future. She enrolled in New Mexico College of Agriculture & Mechanic Arts in the fall of 1928, and taught at the Booker T. Washington School for more than 20 years during a time when the area public schools were segregated. While teaching, she was taking courses only offered during the summer and graduated with a bachelor's degree in English in 1937 at the age of 51. (Courtesy NMSU LASC.)

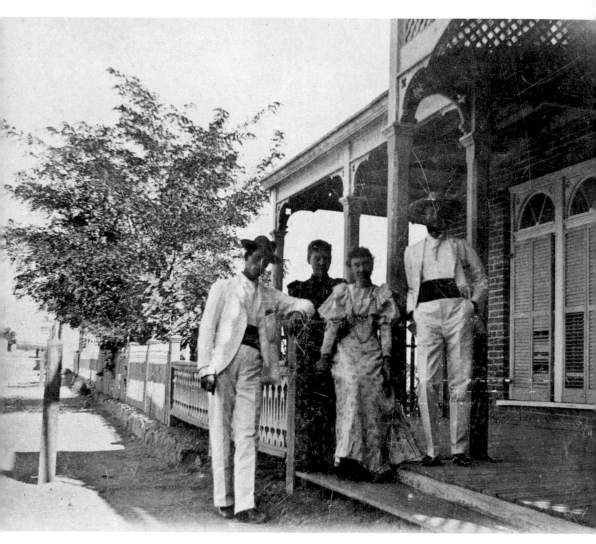

Charles Henry Tyler Townsend (1863–1944)
When Townsend arrived in Las Cruces in 1891 and began serving as a professor of entomology and zoology at New Mexico College of Agriculture & Mechanic Arts, now NMSU, he came with a passion for bugs. His copious notes describing insects found mostly on alfalfa, mesquite, and cottonwood in the Mesilla Valley paved the way for agriculturists and entomologists to better understand the effects of their existence. From left to right are Mr. and Mrs. W.E. Baker and Prof. and Mrs. C.H. Townsend. (Courtesy NMSU LASC.)

Billy the Kid (1859–1881)
When people think of the Wild West, they often think of Billy the Kid and his involvement in the Lincoln County War. Billy the Kid was born William Henry McCarty Jr. on November 23, 1859.

He became a legend in 1881 when New Mexico governor Lew Wallace placed a $500 bounty on his head. Until then he was unknown, but soon rumors began to fly that he killed 21 men. He was killed by Sheriff Pat Garrett in Fort Sumner, New Mexico, in 1881. (Courtesy NMSU LASC.)

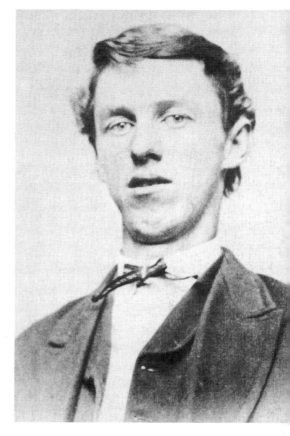

Patrick Floyd "Pat" Garrett (1850–1908)
Garrett was an old-West lawman who became famous by killing Billy the Kid. When he was appointed Lincoln County sheriff, he soon became obsessed with capturing Billy the Kid, and that obsession led to the death of the Kid in Fort Sumner, some saying he killed him in cold blood. (Courtesy Doña Ana County Sheriff's Department.)

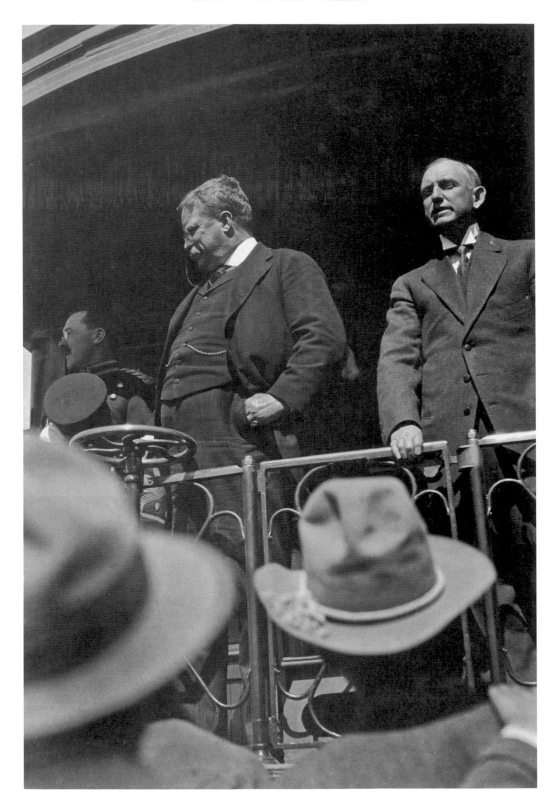

R.L. Young and Theodore Roosevelt (OPPOSITE PAGE)
Pres. Theodore Roosevelt stopped to speak to members of the Las Cruces community at the Las Cruces Train Depot on March 15, 1911. Standing to his right is the second mayor of Las Cruces, R.L. Young. Roosevelt took the oath of office on September 14, 1901, becoming the 26th president following Pres. William McKinley's assassination. At the age of 42, Roosevelt was the youngest man to ever become President. During Roosevelt's 1911 Las Cruces visit, he was touring the Southwest in an attempt to win the Republican Party nomination. Earlier in 1901, Roosevelt, who became a personal friend of Pat Garrett, appointed Garrett as a customs collector in El Paso, Texas. Young became a lifelong public servant in Las Cruces and, because of the impact he had on the area, one of the city's most well-known and popular parks, Young Park, was named after him. (Courtesy NMSU LASC.)

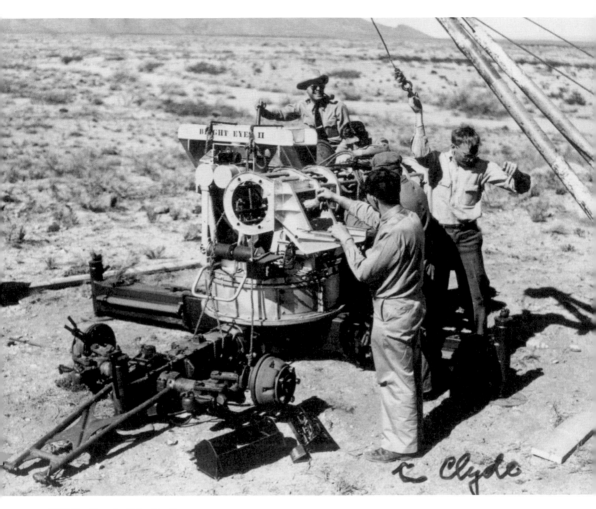

White Sands Missile Range
White Sands Proving Grounds was established in July 1945 by the secretary of war, Robert P. Patterson. It combined the existing government firing and bombing ranges as well as tracts of private and public land. The proving grounds were later named White Sands Missile Range in 1958 and used to test many weapons systems. Because of the research in rocket technology shortly after World War II, WSMR helped propel the country into space and is often referred to as the "Birthplace of the Race to Space." Currently, Brig. Gen. Gwen Bingham is the first female Army officer, and the first African American, to command at WSMR. Two men are pictured here setting up the Little Bright Eyes II telescope at WSMR. (Courtesy NMSU LASC.)

Clyde Tombaugh (1906–1997)
As a teenager living in western Kansas, Tombaugh's hope of going to college was halted due to a hailstorm that destroyed the family's crops. He did not give up on his dream of becoming an astronomer and eventually found a name for himself after discovering Pluto on February 18, 1930. Tombaugh worked at the White Sands Missile Range for nine years. When he left the missile range in 1955, he joined the staff at NMSU until his retirement in 1973. (Courtesy NMSU LASC.)

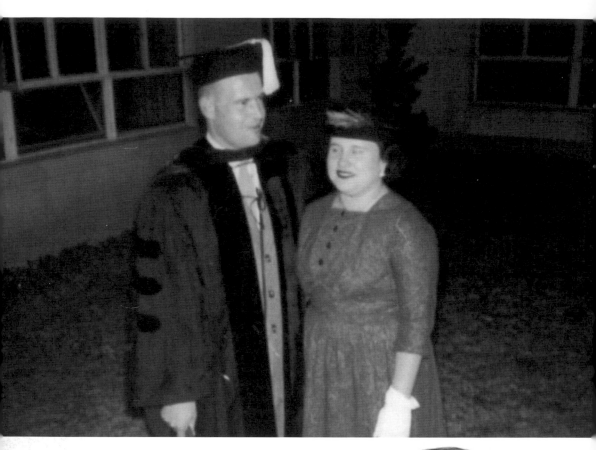

Dr. Allan B. Gray Jr. (1930–2007)

Gray lived life with a passion for education. In 1952, he received his bachelor of science degree, then a master of science in 1956—both degrees were in mathematics and both earned at NMSU. In 1960, Gray became the first doctorate recipient from NMSU, receiving his PhD in mathematics. He taught for 30 years before retiring in 1991. Gray died of cancer June 29, 2007, and in 2013 his wife, Rosemary Gray, donated his doctoral hood and yearbooks to the NMSU Alumni Association, and his PhD robe to the NMSU math department. (Courtesy Rosemary Gray.)

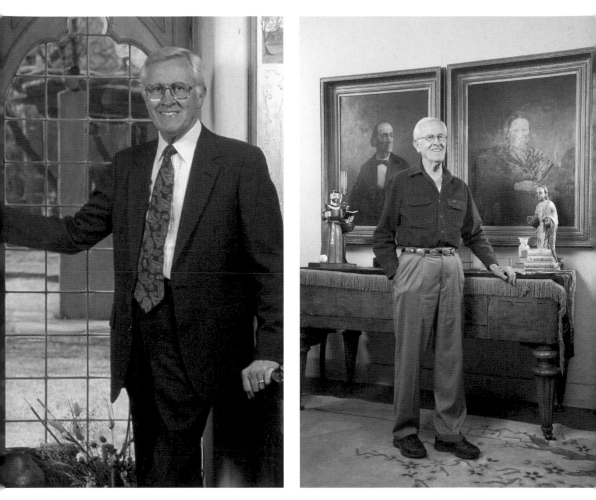

J. Paul Taylor

There are not many in the Las Cruces area who have not heard of J. Paul Taylor, a man whose honesty, modesty, and community commitment has shaped both the towns of Mesilla and Las Cruces as well as the state of New Mexico. Taylor spent more than three decades as a teacher, principal, and associate superintendent in the Las Cruces public school system. After he retired, he served as a representative for District 33 in the New Mexico legislature for nine consecutive terms (18 years). Taylor was married to Mary Daniels Taylor, a historian, paleographer, archivist, writer, and photographer. Mary died in 2007.

In 1947, the Taylors moved to Mesilla with a desire to raise their family in a multicultural community and share their Hispanic cultural heritage with their children. In 1953, they moved into the home J. Paul Taylor still lives in, raising their seven children there. The Taylors, with the generosity so often associated with the family name, gifted their home to the New Mexico State Monument. (Both, courtesy NMSU Alumni Association.)

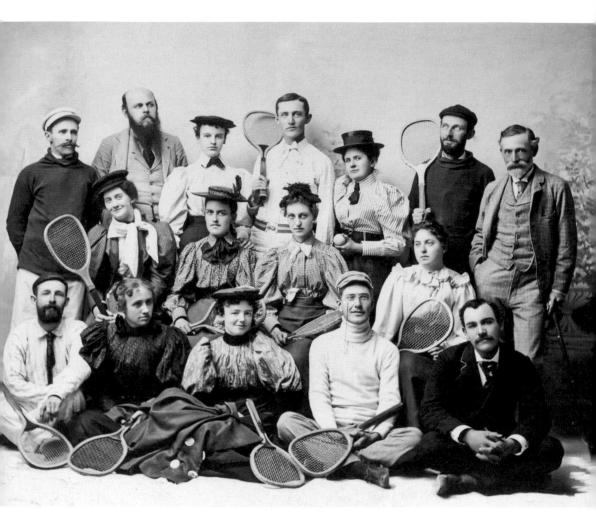

Las Cruces Tennis Club, 1896
With a warm climate and superb year-round weather, Las Cruces has always been a popular place for tennis. From left to right are (first row) C.W. Ward, Katherine Stoes, Alice Branigan, Mr. Stevens, and Jack Fountain; (second row) Edith Dawson, Fannie Blakesley, Miss Granger, and Millicent Barker; (third row) Dr. Elmer Otis Wooton, Dr. Jordan, Miss Freeman, H.B. Holt, Sue Meade, Mr. Freeman, and F.C. Barker. (Courtesy NMSU LASC.)

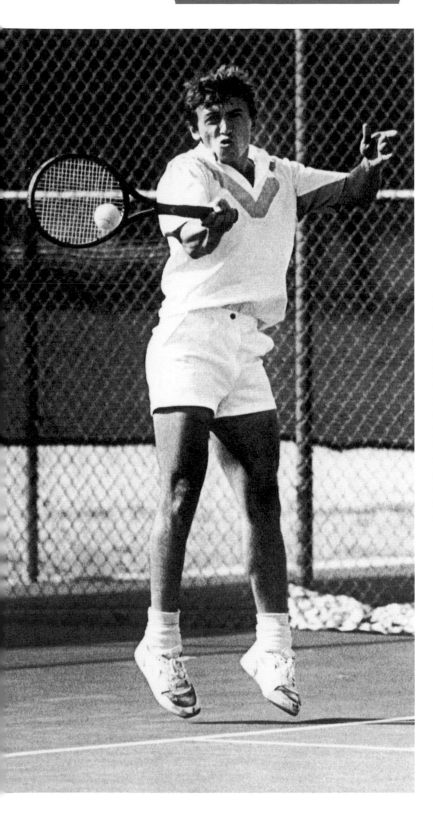

Don Ball
NMSU has celebrated tennis from the very beginning. For 25 years, Don Ball coached the university's tennis teams, including Ernest Husari, who is pictured here taking a shot in 1987. Ball is the longest-tenured coach in school history. (Courtesy NMSU Alumni Association.)

Joseph and Erika Larimer
Joseph and Erika Larimer moved their family to Butterfield Park in the summer of 1964 and soon found water was hard to come by. They took action and formed a water board, Butterfield Park Mutual Domestic Water Association, and eventually helped build a community center in Butterfield Park. Joseph passed away in 1987, and Erika passed away in 1996. The Larimer siblings applied for a street name change and were granted Larimer Lane in 1997 in honor of the work the Larimers did to create a water infrastructure in Butterfield Park. (Courtesy Carlotta Armitage-Medina.)

Fabian Garcia (1871–1948) Garcia's work as a professor of horticulture from 1906 to 1945 changed the face of New Mexico agriculture and has made many chile eaters happy over the years. Garcia was named the first director of the state agricultural experiment station in 1913, and his work produced the first reliable chile pod, which was the beginning of the hot Sandia pepper. Garcia's commitment was not just in the field. Born into a poor family in Chihuahua, Mexico, and orphaned early on, Garcia never forgot about those who might need help, and he often provided rooms on the farm for poor Mexican American students attending school. (Courtesy NMSU LASC.)

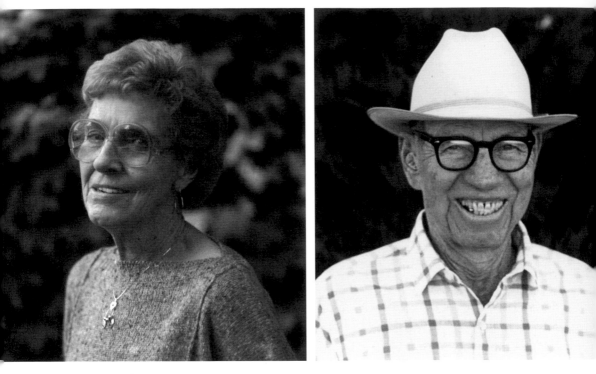

Bamert Family

The Bamert name started in Las Cruces when Michael (1857–1942) first arrived in the county in the 1880s. He met and married Ida Stevens (1872–1955) and the couple lived on their farm in a house still standing today, raising their six children: Carl, Fred, Albert, Max, Anna, and Walter.

Russell Bamert still lives in the house his father and mother, Walter (1910–1996) and Ruth (1912–1988), purchased in 1951. Walter worked the surrounding land, and Ruth ran Century House Antiques next door until her death. Both were greatly involved in the community, leaving a legacy many still remember today. Walter was a state representative in the 1960s, and both were on the Doña Ana County School Board. In 1945, Walter was one of 100 community members who paid $100 for the revival and redevelopment of the New Mexico Farm Bureau.

Russell made a name for himself as a photographer, immortalizing southern New Mexico with his photographs for various national and regional publications, including *New Mexico Magazine*. (Courtesy Russell Bamert.)

Barbara Funkhouser

In 1936, Funkhouser's father died, leaving the family farm in Fairacres to his wife, Lucille Denton Funkhouser. With two young children and an intense desire not to give up, Funkhouser's mom continued to operate the farm with the help of hired labor, Mexican national workers through the Bracero program, and even German prisoners of war during World War II.

Born March 1, 1930, Funkhouser has lived her entire life with the same determination her mother had. She graduated from New Mexico A&M, what is now NMSU, in 1952 with a degree in English, although her focus was journalism. After graduation, she spent six months in Europe on a 4-H Club exchange program and then worked five years for the 4-H organization in Washington, DC, and Chicago. When she returned to New Mexico in 1958, she started a freelance career as a journalist, but said she found that was the quickest way to starvation. She did not starve long and eventually became the first and only woman to serve as an editor at the *El Paso Times*. She was also a founding board member of the New Mexico Farm & Ranch Heritage Museum. (Courtesy Barbara Funkhouser.)

Harold Cousland (1942–2001)
Cousland was the editor of the *Las Cruces Sun-News* from December 1991 until he died at age 58 on September 21, 2001. His 37-year career as a journalist included reporting and editing positions at major papers and small-town weeklies. He was also one of the founders of the Great American Duck Race in Deming (pictured). A scholarship endowment in his name was created within the Community Foundation of Southern New Mexico for aspiring journalists. (Photograph by Norm Dettlaff; courtesy *Las Cruces Sun-News*.)

Sam Lopez (1920–2008)

Entering the military in 1942 as a draftee, Lopez did what he did most of his life—he gave everything he had. Eventually becoming a second lieutenant, Lopez trained the men with the 4th Engineering Amphibious Command, 544th Engineer, Boat and Shore Regiment, and was no stranger to putting his own life on the line. When he settled back in Las Cruces, he became a community advocate. For years, he served with the Sun Rise Lions Club (receiving the highest honor a Lions member can receive), as well as being a member of the Doña Ana Mutual Domestic Water Consumers Association, and as a key player in raising funds for the widely used First Step Center. Lopez often said he wanted to do what he could to be united: united in the war, united in the community, and united with family. When he found an opportunity to visit the National World War II Memorial with Honor Flight of Southern New Mexico and fellow World War II veterans, he jumped at the chance. Unfortunately, Lopez died a little over one month before he was to take the flight. (Courtesy Charlotte Tallman.)

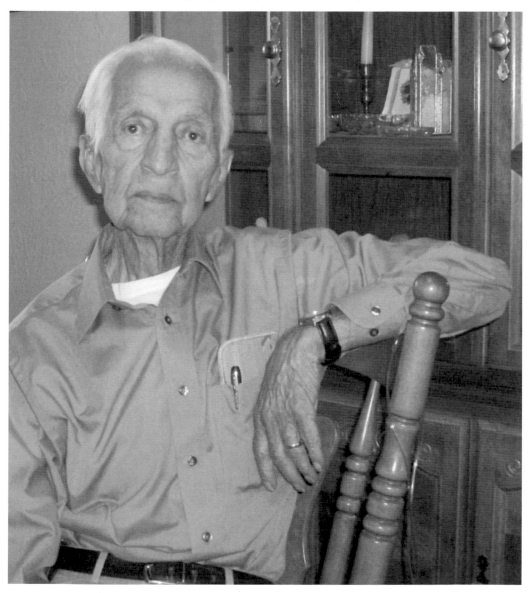

Michael "Mario" Bellestri (1950–2008)

Bellestri left his mark in southern New Mexico as owner and general contractor of Soledad Canyon Earth Builders, a company that he built with his wife of 25 years, Patricia Bellestri-Martinez. The couple built their first rammed-earth home in the then-remote Talavera area. Now, Patricia, their son Max Bellestri, and daughter-in-law Melissa Lucero Bellestri just completed their 75th rammed-earth home, continuing Mario's legacy through Soledad Canyon Earth Builders. (Courtesy Patricia Bellestri-Martinez.)

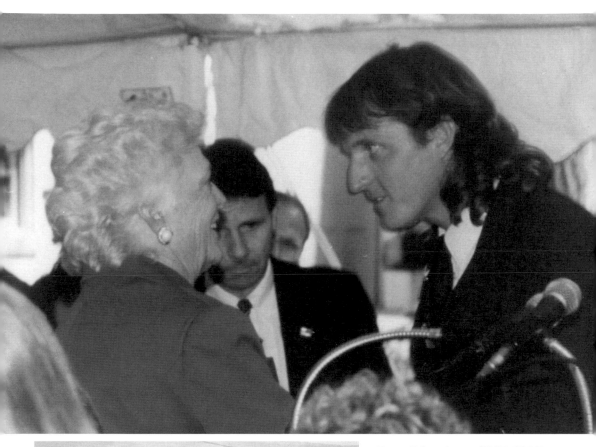

Russell Armitage (1959–2000) Armitage lived with dyslexia for 32 years before deciding it was time to make a difference in his life and the lives of others. Despite earning a high school diploma, Armitage did not know how to read past a third-grade level when he started meeting with a reading tutor. As his reading abilities grew stronger, so did his desire to help others. He started a support group to help others overcome illiteracy and was selected to attend the National Adult Literacy Congress in Washington, DC, where he met first lady Barbara Bush. When Armitage passed away, he left behind his wife Carlotta and children Brian, Shawn, and Stephanie Armitage. (Courtesy Carlotta Armitage-Medina.)

Jon Wynne (1931–2011)
Wynne lived a life devoted to community, philanthropy, and commitment, and he loved to engage in intellectual pursuits and political discussions. His keen and dry sense of humor was embraced by many who knew and loved him, and when he was not volunteering, discussing, or joking, he was logging 40 miles on his stationary bike each day. Wynne spent the majority of his career as an auditor for the American Tobacco Company based in New York City. When he retired to the warmer climate of Las Cruces, he became a community volunteer dedicated to social change and philanthropy. Wynne volunteered with the Community Foundation of Southern New Mexico for nearly two decades, starting with the Memorial Medical Center Foundation. (Courtesy Community Foundation of Southern New Mexico.)

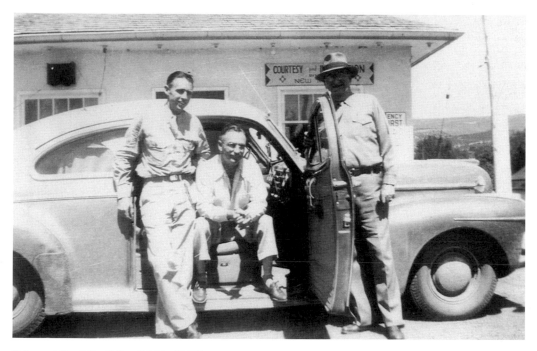

Edward Earl Stull Sr. (1896–1990)
Stull began the family business by purchasing large parcels of land around Las Cruces during the Depression. He also had a heavy hand in politics, serving as the deputy collector of income tax for four years, county tax assessor in 1938, and a state representative for four years. Stull is pictured here between two unidentified people. (Courtesy Laura Kaczmarek.)

Jamie Stull Sr. (1923–2012)
Stull spent his life defending the country and building businesses in Las Cruces. He was a bombardier in the US Army Air Force for five years during World War II in India, China, and Burma. When he returned to Las Cruces, he owned numerous businesses, sold real estate, and was a developer of several local subdivisions. Stull was the president of the State Liquor Association and was a Doña Ana County commissioner. He was married to Ann F. O'Hair and had four children, Karen Stull, Jamie Stull Jr., Patrick Stull, and Laura Kaczmarek. (Courtesy Laura Kaczmarek.)

Bob Porter (LEFT, ABOVE, AND OPPOSITE PAGE)
Porter is no stranger to agriculture—he spent his
entire life around it. He was born in 1929 during the
Great Depression on a dry land farm. When he was a
year old, he and his family moved from the panhandle
of Texas to Las Cruces where his dad was a farm
laborer. It was not long before his father bought the
Sage Farm near Salem and the family lived in a jacal,
working their 45 acres of land. He is shown on the
opposite page in 1937 with his third-grade class in
Salem, New Mexico.

During his time at NMSU, Porter played
basketball for the Aggies and was in the Air Force
ROTC. When Porter graduated, he went into
agriculture, starting with the Bracero Program,
which imported temporary contract laborers from
Mexico to the United States. He concluded his
career by spending 14 years as the CEO of the
State of New Mexico Farm and Livestock Bureau.
(Courtesy Bob Porter.)

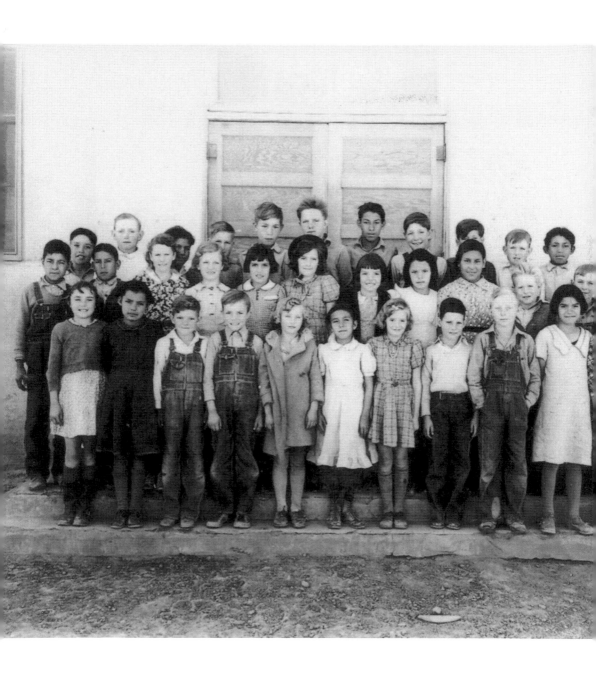

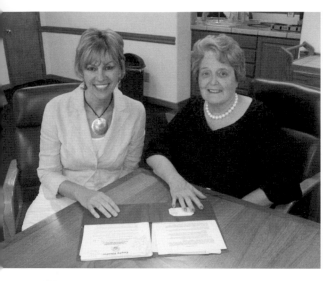

Patsy Duran

Duran knows no bounds when it comes to philanthropy and civic loyalty. Over her many years in Las Cruces, she served with the Bridge of Southern New Mexico, on the board of directors for The Greater Las Cruces Chamber of Commerce, the National Committee on Planned Giving, the Association of Healthcare Philanthropy, the White Sands Missile Range Historical Foundation, Children's Miracle Network's board of directors, the Las Cruces Mesilla Valley Rotary Club, Las Cruces Public Schools Board of Education, the Junior League of Las Cruces, and the Association for Commerce and Industry—just to name a few. She was a member of the New Mexico State University Foundation, serving as director of library development before becoming vice president for resource development and executive director of the Memorial Medical Center Foundation. Before retiring and moving to Florida, Duran passed the leadership of the Community Foundation of Southern New Mexico on to Luan Wagner Burn, shown at left.

She is now residing in Panama City Beach, Florida, and serves as the president of the Panama City Beach Library Foundation, Inc. (Left, courtesy of the Community Foundation of Southern New Mexico; right, courtesy Patsy Duran.)

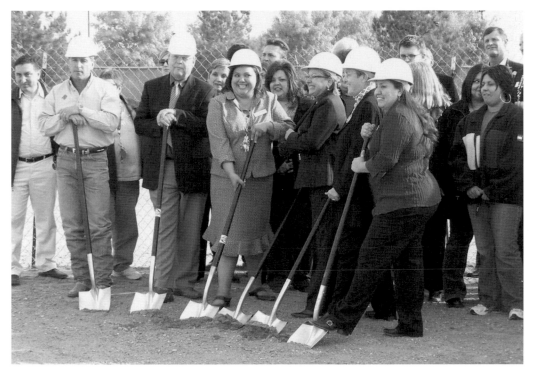

Gina Orona-Ruiz (1967–2011)

Orona-Ruiz touched the lives of many men, women, and children as the executive director at La Casa Domestic Violence Center for 16 years. Orona-Ruiz received recognition nationwide and statewide for being an expert in the domestic violence movement, and was always available when others needed her expertise on anything related to domestic violence. When she died, she left behind hundreds of people who found comfort in her organization and her children, Gabriela and Joshua Ruiz. (Courtesy Debbie Orona.)

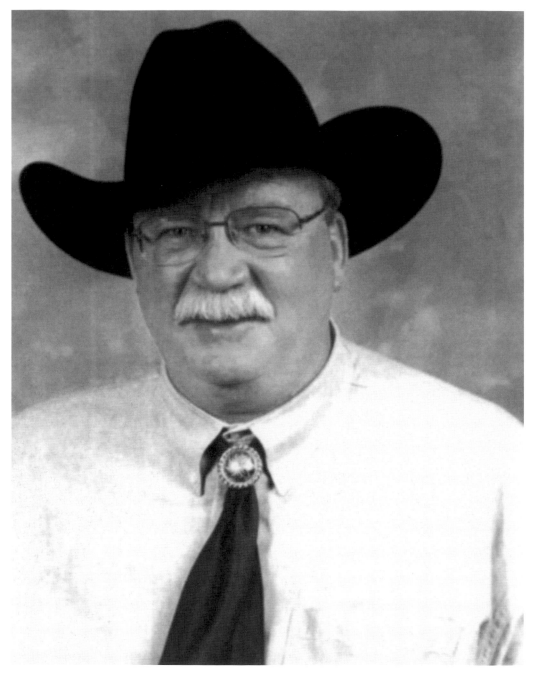

Frank A. DuBois
DuBois retired as the New Mexico secretary of agriculture in 2003 after serving as director of New Mexico's Department of Agriculture for 15 years and as cabinet secretary for four governors' terms. During his career, DuBois worked as field inspector, agricultural policy specialist, and assistant director of the department. He was assistant director of NMDA when he was selected as director and secretary by New Mexico State University's Board of Regents in February 1988. (Courtesy New Mexico Department of Agriculture.)

Terrance Puckett (1940–2003)

Puckett knew no judgment when it came to the homeless. He served as the manager of the Gospel Rescue Mission from 1995 until he suffered a stroke in 2002. During his time as manager, many homeless lives changed because of his belief in them. Since his death, several formerly homeless men and women returned to the mission to donate time and money in his honor. (Courtesy LuAnne Burke.)

Olga Granado (1954–2010)
Granado was many things in her life but the one word that many friends and family would use to describe her is dedicated. Granado was involved with the Las Cruces community for over 20 years at the time of her death. She volunteered with many agencies like Habitat for Humanity and the Community Action Agency, but she had a special place in her heart for inmates and their families. In 1992, she started as a Prison Family Services coordinator at the Southern New Mexico Correctional Facility, eventually becoming the director of the Hospitality House at the prison. Her mission was to make sure relationships were preserved when one or both parents were incarcerated. (Courtesy Karma and Charles Brewster.)

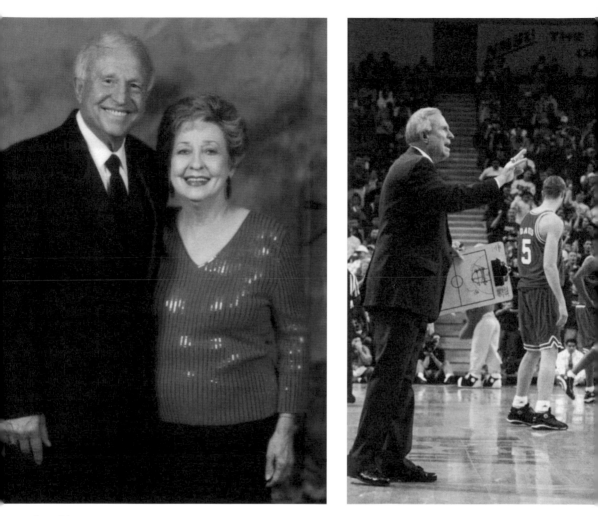

Lou Henson

Henson played basketball at NMSU, returning to his alma mater during a successful coaching career that spanned 53 years. He began coaching at Las Cruces High School in 1959, winning three state titles before moving into the college ranks in 1962 at Hardin-Simmons University. During his nine seasons at NMSU, he led the Aggies to six NCAA tournaments and four 20-win seasons, compiling a 173-71 record. After retiring in 1996, NMSU asked him to return just before the season opened, and he stayed until 2005 posting a 135-86 record, which included three more NCAA tournament appearances.

Henson is married to Mary, and together the couple has become legendary in the Las Cruces community because of their philanthropy. (Courtesy NMSU.)

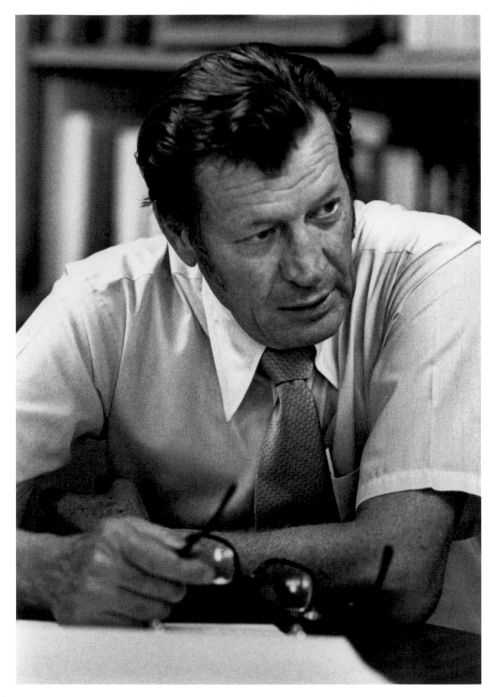

Gerald Thomas (1919–2013)
Thomas's impact was great, both in Las Cruces as president of NMSU from 1970 to 1984, and overseas as he served as a US Navy carrier-based naval torpedo pilot, serving in both the Atlantic and Pacific, where he survived a splashdown in the South China Sea. Following his time as a pilot, Thomas wrote *Torpedo Squadron Four—A Cockpit View of World War II*. He was awarded three Distinguished Flying Crosses, two Air Medals, and the Presidential Unit Citation. (Courtesy NMSU LASC.)

CHAPTER FOUR

Legends of Today

There are so many legends of the area who are honored or recognized on a daily basis.

Gov. Susana Martinez is one of those legends. Martinez was born on July 14, 1959, in El Paso, Texas, and was raised in a middle-class family. Her father was deputy sheriff for El Paso County and an amateur boxer, taking home three Golden Gloves titles in the 1950s.

Martinez earned her bachelor's degree from the University of Texas at El Paso in 1981, and her law degree from the University of Oklahoma College of Law in 1986. When she moved to Las Cruces, she served as an assistant district attorney for the Third Judicial District in Doña Ana County from 1986 to 1992. Then she became the district attorney in 1997 and was reelected to the position three times. Martinez won the Republican nomination for governor of New Mexico in the June 1, 2010, primary election, then became the first female governor of New Mexico and the first female Hispanic governor in the country.

While Martinez is known by many for her role as governor, the community remembers her for her advocacy. She played an important role in many child abuse cases, prosecuting each with an intense passion. Because she highlighted shortcomings in the child abuse law, particularly the law that only allowed for a maximum of 18 years in prison when a person was convicted of intentional child abuse resulting in death, others got involved, eventually bringing change the community applauded.

Working closely with Martinez on many issues victims face was Donna Richmond. Her father, Sgt. Thomas Arlen Richmond, was killed in the line of duty during a routine traffic stop. After the death of her father, Richmond devoted her life to victims. When the man who killed Richmond's dad went to prison for a life sentence, she tried to find out where he was housed—making more than 15 phone calls, and eventually finding the information she was looking for three days later. Richmond realized she, and other victims, just wanted to know where their offenders were for peace of mind.

In order to help provide that peace of mind, Richmond helped bring the Victim Information & Notification Everyday Service to Doña Ana County, a free and anonymous computer-based telephone program that provides information and notification of offenders, allowing victims to stay up-to-date on where their offenders are and when court dates will be.

Bringing VINE was not enough for Richmond. In 1995, she started working on the Southern New Mexico Peace Officers Memorial honoring fallen officers, then went on to become a volunteer victim advocate for the Victims Assistant Unit with the Las Cruces Police Department. In 2002, Donna applied for a job as victim advocate coordinator for the Sheriff's Department, then moved on to the district attorney's office as a victim advocate coordinator. The work with victim advocacy prepared her for her current position at La Piñon Sexual Assault and Recovery Services, which she took over from Louise Tracey-Hosa, who was instrumental in building up the highly successful sexual assault recovery service.

Like Richmond, Dinny Bomberg used her grief to help others. In 2003, Bomberg's 30-year-old daughter Becky Prichard died in a tragic drowning accident, but Bomberg was not going to let her daughter's legacy die with her. After graduating from St. Paul's Central High School in Minneapolis and attending the University of Minneapolis, Prichard and Bomberg traveled around Latin America over four months before Prichard settled for a time with her aunt in New Zealand. In 2000, Bomberg took her

yearly volunteer vacation to build a house in Bolivia through Habitat for Humanity Global and suggested Prichard meet her in Peru so they could travel to the ruins of Machu Picchu. By 2002, Prichard was remodeling an old building for a second-floor restaurant in Pisac and was engaged to Mendel Wilson Muñiz, a Peruvian whitewater guide. Her love for the Peruvian children was evident and she was involved as the treasurer for the school Muñiz's daughter attended, raising funds for basic supplies.

On June 9, 2003, Prichard and Muñiz were driving from Cuzco to Calca when their car blew a tire and slid into an eddy of the Urubamba River. Muñiz was able to get out, but Prichard's foot was caught in her seat belt and she drowned. After Prichard's death, Bomberg created The Becky Fund, an organization created to aid the children of Peru. Four years after Prichard's death in 2007, Bomberg's son Mike died in an accident at his home when he was 40 years old. Bomberg now continues the Becky's Fund effort in memory of both her children, taking both Las Cruces residents as volunteers and others across the nation.

Luan Wagner Burn knows a thing or two about making a difference. As the executive director of the Community Foundation of Southern New Mexico, she works tirelessly to help concerned community members make a difference now and in the future with special funds and endowments. Through her leadership, she is also able to provide opportunities for a whole host of individuals and groups who want to raise money for a cause, from buying heaters during a freeze to increasing awareness of prescription drug abuse—Burn makes things happen.

These are just some of the legends who are shaping Las Cruces, minute by minute, day by day, but there are so many others. They take their grief, or happiness, or compassion and turn it into a new experience, a new organization, or a new life. They are the legends of today.

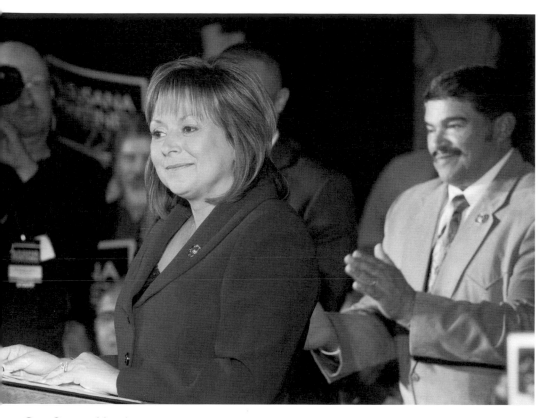

Gov. Susana Martinez

Martinez was elected as the governor of the state of New Mexico on November 2, 2010, making her the first Latina governor in the United States. Prior to being elected governor, Martinez served as the district attorney for the Third Judicial District in Doña Ana County for 14 years, personally trying some of the toughest cases in New Mexico.

Accolades come frequently for Martinez because of her compassion and dedication to the community. In 2008, *Heart Magazine* named Martinez Woman of the Year for her dedication to children's advocacy and her efforts to keep children safe. She was twice named New Mexico's Prosecutor of the Year. In April 2011, *Hispanic Business Magazine* named Martinez Woman of the Year.

Martinez was born and raised in the Rio Grande Valley. She earned her bachelor's degree from the University of Texas at El Paso and later earned her law degree from the University of Oklahoma. She is married to Chuck Franco, a former Doña Ana County undersheriff. (Courtesy Bill Faulkner.)

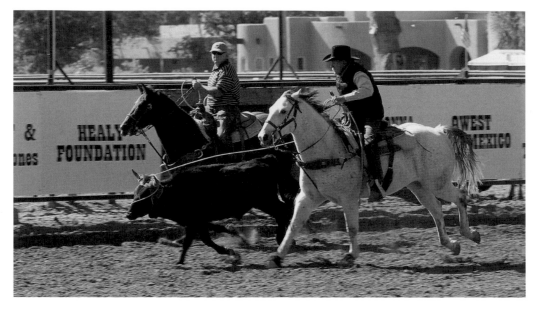

Cowboys for Cancer

In 1981, Alma Cohorn, wife of roper Kenneth Cohorn, died of cancer. To honor her memory, members of the Las Cruces community pulled together for the first team roping competition to raise money for the fight against the disease that took the life of their good friend. Now one of the largest roping events in New Mexico, the Cowboys for Cancer Research Team Roping event draws teams from New Mexico and west Texas for cash and donated prizes. The Tough Enough to Wear Pink campaign started at NMSU in 2007 with a NCAA college football version of the premier Wrangler rodeo event. Since then, more than $2 million in cash and in-kind contributions have been raised, and all the money goes to Cowboys for Cancer. (Courtesy Geraldine Calhoun.)

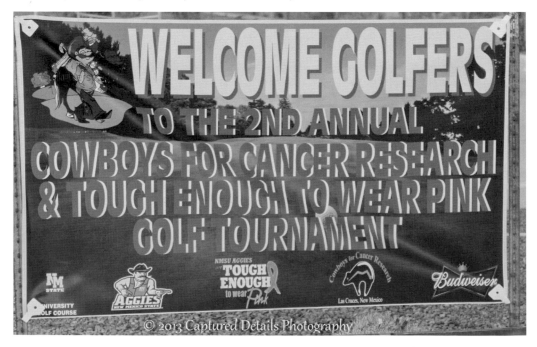

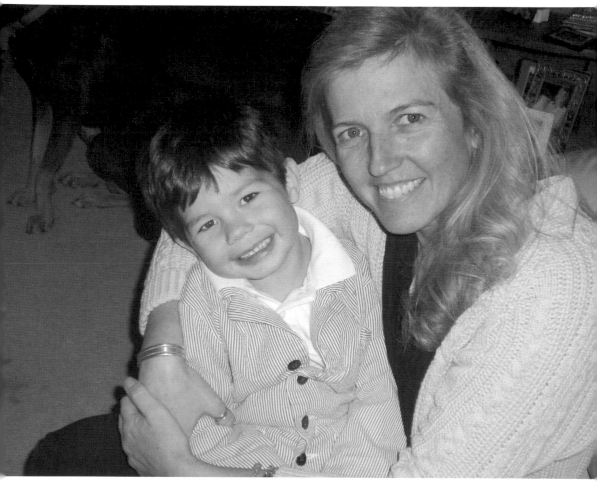

Donna Richmond
Richmond has spent the majority of her life being there for victims, starting as one herself. On July 13, 1988, her father, Sgt. Thomas Arlen Richmond, was shot and killed in the line of duty during a routine traffic stop in Mesilla. Since that time, Richmond has devoted her life to advocacy. As the executive director of La Piñon Sexual Assault and Recovery Services of Southern New Mexico, she helps make life better for the victims who often don't know where to go. Donna has three children, Chelsea and Carlea Duplantis, and Andre Richmond. (Courtesy Donna Richmond.)

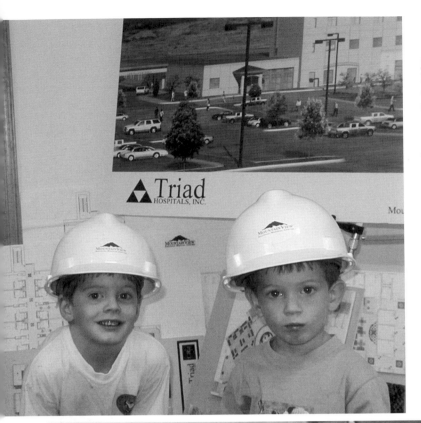

John Hummer
Hummer arrived in Las Cruces in 2000 to develop and lead the area's second hospital, MountainView Regional Medical Center. As CEO of the hospital, he devoted an enormous amount of time and experience to the hospital and the growth of the community. In 2006, Hummer—along with his wife Amy Carmichael—changed gears, acquiring Steinborn Inc. Real Estate and he became the thriving company's owner and CEO.

The Hummers have two sons, Alex and Sam, shown in hospital hardhats in 2000. (Courtesy John Hummer.)

Christina Little

Since 2004, Little has managed the Interagency Council, which provides a network for social service providers in Doña Ana County. Her valuable community-related messages are communicated daily, and she heads up information meetings once a month. To better increase advocacy in the community, Little coordinated the development of Community Connect, a database of social and community services maintained by the United Way of Southwest New Mexico. (Courtesy Christina Little.)

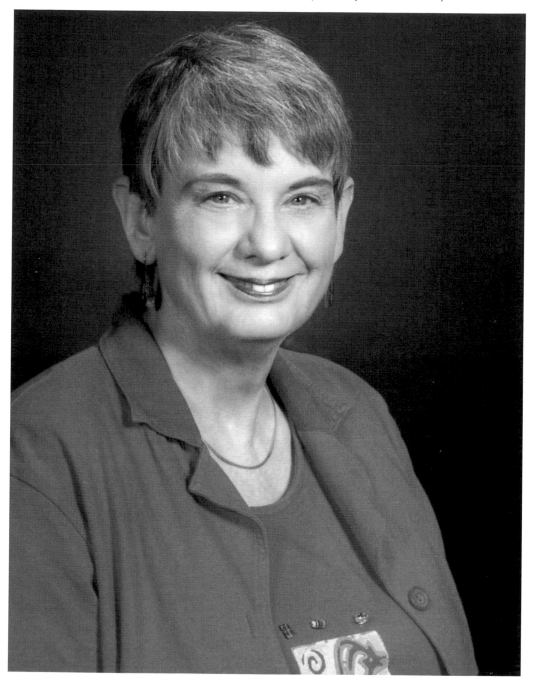

Eddy Harrison

Listening to Harrison play a guitar is magical. His music is warm, rich, and flowing. The beauty of the music is outmatched only by the guitar he plays: made from scratch in his workshop with intricate details like turquoise and ebony inlays.

Harrison began as a woodworker, running his own business out of Mesilla Park for more than 30 years and playing music and traveling to Western Music Association events with his wife, Janet, when he was not working. Eventually, he began experimenting with the physical appearance of his instruments. The attention to detail Harrison shows is amazing, like lapis roses with intertwining rivers of real turquoise and simulated lapis lazuli, cloisonné red rose accents, and hand-inlaid turquoise. (Courtesy Lincoln Michaud.)

Donny Grooms

Grooms is a KRWG development officer at NMSU, but he shines as a community advocate for events like the Red Ribbon Bash, the annual fundraiser for the Southern New Mexico Aid & Comfort Program of which he is an organizer, and Look Who's Dancing, a fundraiser benefitting NMSU Dance Program and DanceSport Society. (Courtesy Donny Grooms.)

Shawn and Amy Stalls (BELOW AND OPPOSITE PAGE)
Long before the Stalls started their company, Phoenician Custom Homes LLC, they learned what loss felt like on a level too deep. The couple, living in Phoenix, welcomed Zachary Alan into the family and began to build the life they always wanted. When the couple lost young Zachary (opposite, top) at the age of five to meningitis, their world shattered. Working desperately to overcome their loss, Shawn and Amy tried for another child—joyfully welcoming daughter Riley in 2004. It was the chance the couple needed to move on with just the memory of Zachary, but the family never made it home from the hospital. Riley was born with a genetic disorder that took her life when she was three weeks old.

To acknowledge the end of one life and the start of another, the Stalls moved to Las Cruces and started their company with the Phoenix as their logo—a mythological bird that is consumed by fire in its nest at the end of a life cycle, then from the ashes comes a new, young Phoenix. To the Stalls, the new life is the birth of their two sons, Hayden and Ryan (opposite, bottom). (Courtesy Amy Stalls.)

Preciliana Sandoval
As owner and operator of La
Morena Walking Tours, Sandoval
is a self-taught Mesilla Valley artist,
muralist, and storyteller. Dressed as a Mexican
revolutionary woman of the 1800s, Sandoval
shares stories of the past and present during her
walking tours of Mesilla and the surrounding
area. With a deep understanding of the culture,
and an even deeper understanding of the spirits
that still walk the ground, Sandoval brings even
the dullest story to life with her animated
expressions as she recreates history. (Courtesy
Lincoln Michaud.)

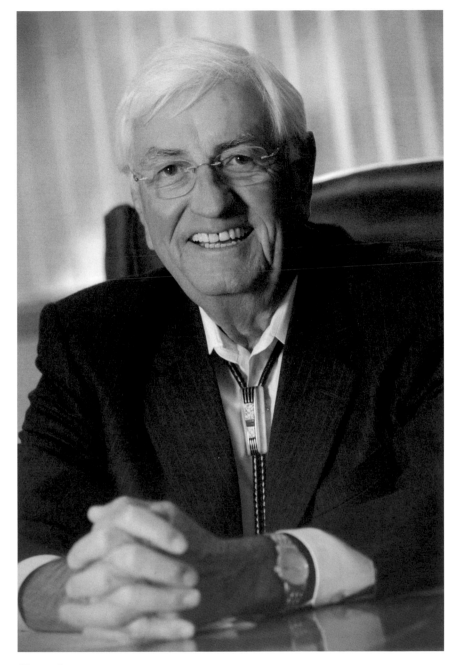

Garrey Carruthers
Carruthers is fond of the number 27. He was elected the 27th governor of New Mexico in 1987 and the 27th president of NMSU in 2013. He also served as a White House fellow assigned to the secretary of agriculture, the assistant secretary and president of the United States Department of the Interior, and he created the Cimarron Health Plan in 1993 and served as president and CEO. Carruthers was dean of the NMSU College of Business and vice president for economic development and director of the Pete V. Domenici Institute when he became president of the university. He and his wife, Kathy, have been married for more than 53 years. They have three children and six grandchildren. (Courtesy NMSU Communications.)

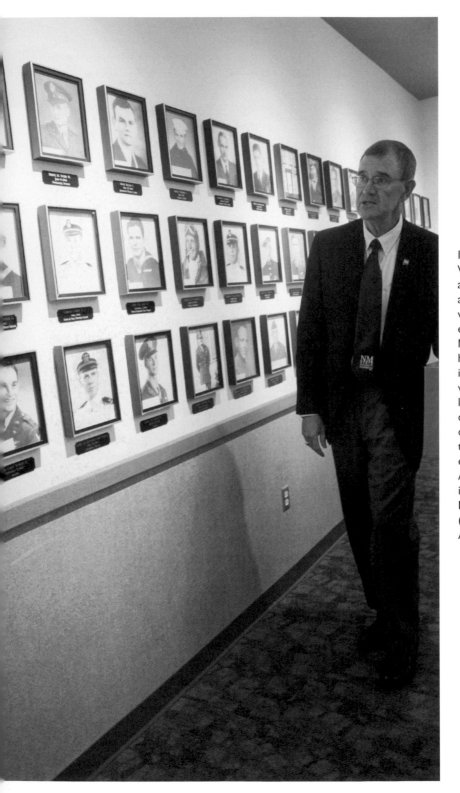

Benjamin Woods Woods serves as chief of staff and the senior vice president for external relations at NMSU, but to many, his greatest impact is in memory of those who have lost their lives defending the country. Woods has devoted extensive time researching each of the fallen Aggies memorialized in the Aggie Memorial Tower. (Courtesy NMSU Alumni Association.)

Jeff Witte

As the secretary of agriculture for the state of New Mexico, Witte often travels the world to discuss New Mexico's agriculture industry. He has expanded New Mexico agriculture, including pecans, to areas like China, creating a partnership and encouraging food growth worldwide. (Courtesy New Mexico Department of Agriculture.)

Dr. James Shearer
Many students at NMSU have an affinity for music after taking classes with Shearer, a regents professor of music. That appeal comes from his celebrated experience and ability to excite passion for music. He has toured extensively as a member of the Eastman Wind Ensemble and as a soloist with many other ensembles. He has recorded with the Eastman Wind Ensemble, the Creole Dixieland Jazz Band, blues artist Eric Bibb, bluegrass musician Steve Smith, and Memphis Beale Street legend Charlie Wood. (Courtesy James Shearer.)

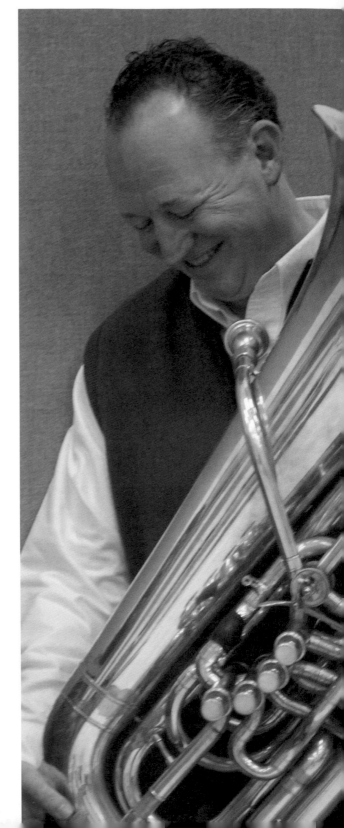

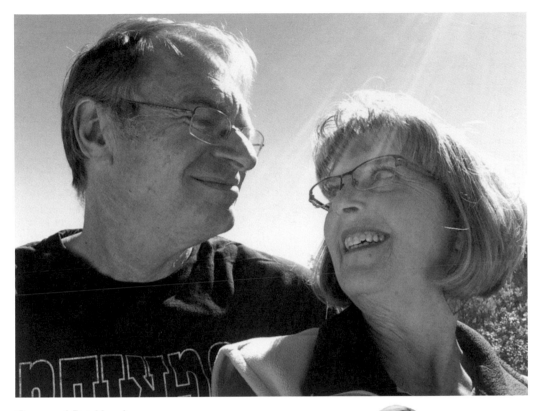

Gary and Pat Henderson
The Hendersons are a humble couple, always behind the scenes but usually at every scene, especially at Calvary Baptist Church where they have served in a variety of capacities for 24 years. Along with the thousands of hours they have helped at Calvary, Pat focused the majority of her life taking care of her family as a homemaker and Gary has been a pharmacist for 40 years. Married 39 years, they have two daughters, Kelly Thompson and Michelle Santana, and one granddaughter, Abigail Kelly Thompson. (Courtesy Pat Henderson.)

Rich '88

Richard Beem
Beem is a golfer on the PGA tour. He grew up in El Paso and graduated from NMSU with a degree in marketing. His talent took him to the professional stage in 1994. In 2002, he won The International in Castle Rock, Colorado, and two weeks later he won the PGA championship at Hazeltine National. He was then named one of the top 20 of the Official World Golf Rankings. (Courtesy PJ Norlander.)

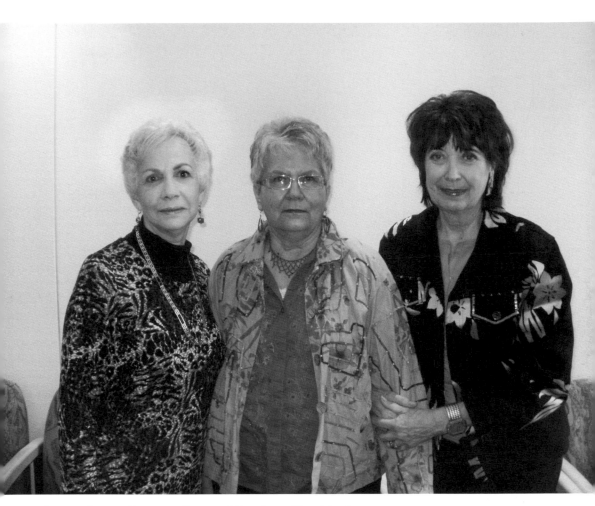

Breast Cancer Support Group of Southern New Mexico
When Bernadette Valdes lost her sister to ovarian cancer, she yearned for a group that could help her through the loss. When she herself was diagnosed with breast cancer a year later, she needed a group to help her understand her illness and offer much needed support. Seventeen years ago, as a trustee of what was then the Memorial Medical Center Foundation, now the Community Foundation of Southern New Mexico, Valdes spoke to the foundation about the needs for a support group and BCSG was formed with the CFSNM as its sponsor.

In addition to support, the BCSG created the Endowment to Fight Cancer in Southern New Mexico through the CFSNM. The group also has a special projects fund, which is used to cover the costs of mammograms for women who do not have health insurance or who do not have enough insurance.

Pictured here from left to right, Lydia Duran, Josephine Wiskowski, and Bernadette Valdes are chairs of the Breast Cancer Support Group of Southern New Mexico. (Courtesy Bernadette Valdes.)

Margaret McCowen

McCowen has a long Aggie legacy. Her paternal grandfather, Henry Crecilius McCowen, graduated from New Mexico College of Agriculture & Mechanic Arts in 1912 and was one of the initial editors of the university newspaper *The Round Up*. Her mother, father, brother, and sister are all Aggie graduates as well. McCowen earned her bachelor's degree in social welfare in 1971, then went on to earn her master's degree in the same subject at the University of Texas, Arlington, and her master's of business administration at the University of New Mexico. She has had a long and distinguished career in the field of social work and mental health. (Courtesy NMSU Alumni Association.)

Michelle Ugalde

In 2005, Doña Ana County sheriff's deputy Michelle Ugalde started GREAT, a gang resistance, education, and training program in DAC. The school-based law enforcement officer–instructed classroom curriculum focuses on prevention in an effort to decrease delinquency, youth violence, and gang membership. Deputy Ugalde expanded on GREAT and started the Be Great Camp at the Boys and Girls Club.

As passionate as Deputy Ugalde is for her own community, she is equally passionate about changing the world around her. In January 2013, she represented DAC and the United States as part of the Law Enforcement Torch Run final leg for the 2013 World Special Olympics in Pyeongchang, South Korea. (Courtesy Michelle Ugalde.)

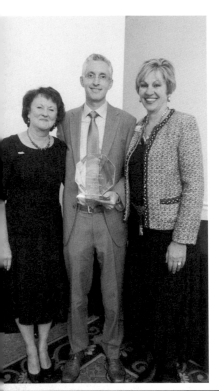

The Community Foundation of Southern New Mexico

The Community Foundation of Southern New Mexico was founded in 2000 with a mission to help the southern New Mexico community now and in the future. A driving force behind the CFSNM was Richard and Nancy Gregory, a couple who spent much of their time encouraging philanthropy and estate planning. The Gregorys began working with the CFSNM from the start; throughout the years, Richard was instrumental in taking the CFSNM to the next level, establishing endowments and educating on philanthropy and education. He then helped create the Estate Planning Institute in 1992, which is still going strong today.

In 2013, Jeremy and Cynthia Settles were named philanthropists of the year by the CFSNM. Pictured at left from left to right are the president of the CFSNM Karen Bailey, Jeremy Settles, and executive director of the CFSNM Luan Wagner Burn.

The foundation offers opportunities for local people who want to give back through scholarships, endowments, and funds. The foundation brought $435,000 of new funding to the community in 2012, and with the services and expertise offered, 42 community groups were able to raise money for their causes without having to form their own charity. The Young Philanthropists is one of the programs created by the CFSNM. Pictured below from left to right are Young Philanthropists Emily Calhoun, Virginia Martinez, Mandy Leatherwood, and Sara Grooms. (Courtesy CFSNM.)

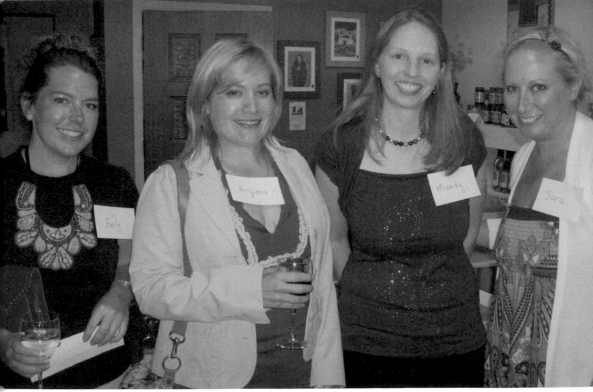

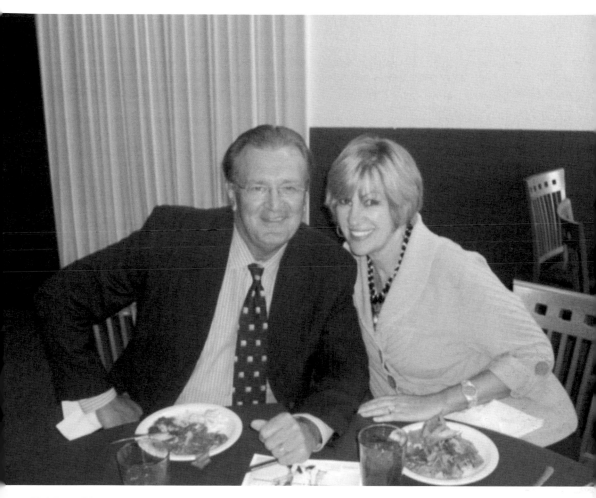

Keith and Luan Burn

Keith and Luan Burn devote much of their time to the community, and they have fun doing it. Keith has practiced law for more than 40 years and was the lead council in many significant cases in New Mexico. He maintains many friendships he has had in the area for decades and is a wealth of information regarding the community's past. An avid piano player, Keith shares his talent weekly at the Picacho Country Club. Luan is the executive director for the CFSNM. Luan has extensive experience in nonprofit work and fundraising, and her role as executive director has had a significant impact on the community as a whole and on many nonprofit organizations throughout southern New Mexico. (Courtesy CFSNM.)

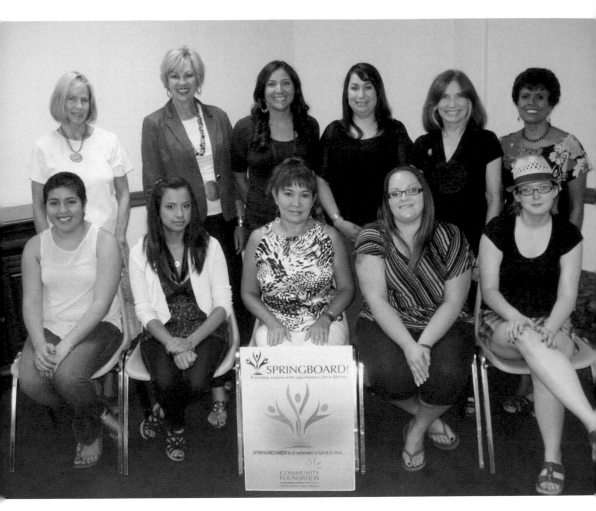

SpringBoard!

In 2004, the SpringBoard! scholarship program was created by the CFSNM and a group of women concerned with the educational advancement of women. Many of the women who receive the scholarship are single mothers and nontraditional students without the means to attend without financial assistance. One of the scholarships awarded through SpringBoard! is the Over the Rainbow Scholarship, established to honor the memory of Dorothy Ellen Baker, a daughter of an Appalachian coal miner who valued higher education for women.

Recent SpringBoard! recipients from fall 2013 are, from left to right, (first row) Haydee Zaragosa, Claudia Bautista, Mayanin de Santiago, Ashley Barreras, and Maggie Gracyalny; (second row) SpringBoard! committee member M. Lea Brownfield, executive director Luan Wagner Burn, Lillian Valles, Elizabeth Evans, SpringBoard! committee member Nancy Baker, and SpringBoard! committee member Ammu Devasthali. Recipients not pictured are Raquel de la Cruz, Rosa Herrera, Jeanne Huang, Ana Pena Soto, and Dalys Sanchez de Arroyo. (Courtesy CFSNM.)

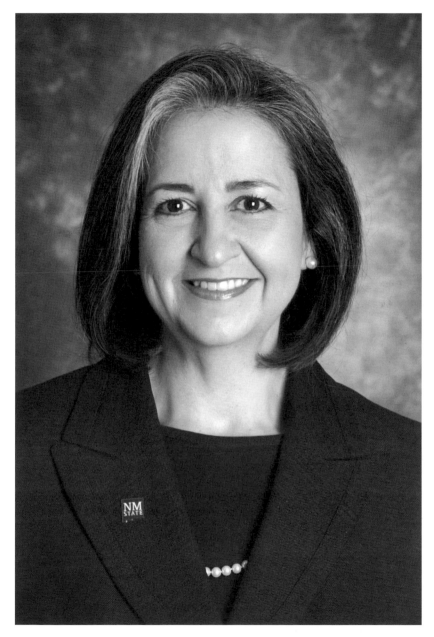

Tammie Campos

Campos is no stranger to NMSU. She received all three of her degrees there, most recently her doctorate, and has worked extensively on the NMSU campus serving as adjunct faculty in the College of Agricultural, Consumer, and Environmental Sciences and working in institutional research. Now as the executive director for the NMSU Alumni Association, she is sharing her affinity for the university with more than 122,000 alumni across the nation.

Campos has worked in higher education for more than 20 years serving in many capacities including institutional research and planning, enrollment services, student affairs, and most recently as the assistant dean of students at the University of Texas, El Paso. She travels extensively as a consultant for conferences on higher education. (Courtesy NMSU Alumni Association.)

The A. Fielder Memorial Safe Haven and Operation Weed & Seed

The A. Fielder Memorial Safe Haven was designed to provide young people and community residents with a secure, visible neighborhood facility that provides educational and productive activities in a safe venue with adequate supervision. Operation Weed & Seed is a multi-agency strategy that "weeds" out violent crime, gang activity, drug use, and drug trafficking in targeted high-crime neighborhoods and "seeds" the target area by restoring these neighborhoods through social and economic revitalization.

The Safe Haven opened its doors in February 2001, and in 2005, Operation Weed & Seed began after three Las Cruces police officers, headed by former Las Cruces police officer Lauris Gallegos, wrote a grant for the program. First gentleman of New Mexico Chuck Franco worked with young men and women for two years as a teen coordinator with A. Fielder Memorial Safe Haven Weed & Seed. One of the largest and most successful programs at the Safe Haven is the Girl Scout troop (pictured). (Courtesy Mandy Leatherwood.)

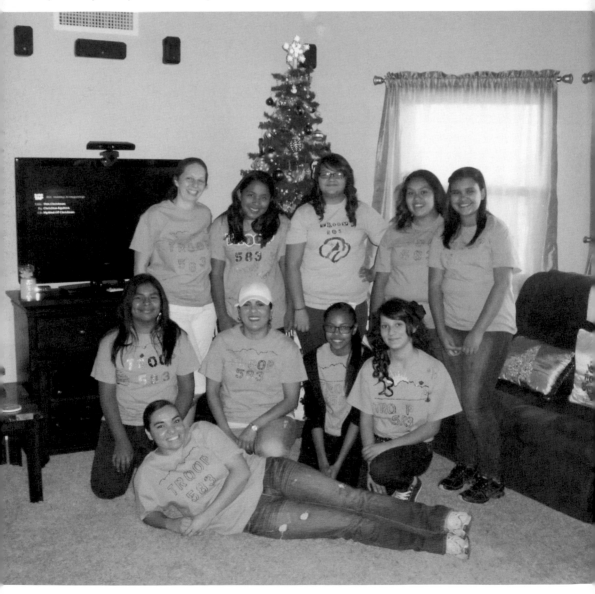

Becky Horner
As the division director for the March of Dimes in southern New Mexico since 1992 (and co-owner of PTS Office Systems Inc.), Horner has made huge strides in the organization's community outreach. She now heads up a highly successful High Heels for High Hopes Style Show, raising $164,398 for the March of Dimes at the sixth annual show in 2012. (Courtesy Becky Horner.)

High Heels for High Hopes (OPPOSITE PAGE)
Since 2006, 176,000 fewer babies have been born too soon in the United States because of reductions in the pre-term birth rate, which has dropped to its lowest rate in 15 years. The March of Dimes of southern New Mexico is able to raise valuable life-saving funds for advocacy, research, and medications in part because of events like the High Heels for High Hopes Style Show, which was in its seventh year in 2013. Each year leading up to the event, a team of stylists, choreographers, and models prepare for a stunning show bringing together philanthropy and entertainment. Models raise funds—a total of $164,398 was raised in 2012 during the A Girl for All Seasons Style Show—with all the money staying within the March of Dimes.

That money helps families like the Johnson family. When Nicole Johnson, married to Wylie, gave birth to Mia, she experienced many emotions, but the strongest was not happiness like many new mothers feel, but guilt. Mia was born six and a half weeks early and was quickly taken to the special care nursery. When Nicole's son David was also born premature, she had the education and advocacy provided by the March of Dimes to help get her through the hard times. Thanks to life-saving medicine through the March of Dimes, both Mia and David are healthy and thriving, serving as the 2013 High Heels for High Hopes and March of Dimes Ambassador family. (Courtesy March of Dimes.)

Dinny Bomberg and The Becky Fund

When Las Crucen Dinny Bomberg visited Calca, Peru, in 2003, she was dealing with a broken heart—her 30-year-old daughter Becky Prichard had just died in a tragic drowning accident. It was when Bomberg heard from a teacher at a beloved school of Prichard's that she always promised to come back and help with the deplorable conditions of the school, that Bomberg created The Becky Fund, an organization created to aid the children of Peru. Four years after Becky's death in 2007, Bomberg's son Mike died in an accident at his home when he was 40 years old. Bomberg now continues The Becky Fund effort in memory of both her children, taking both Las Cruces residents and others across the nation as volunteers. (Courtesy Dinny Bomberg.)

Karma and Charles Brewster
The Brewsters have spent a lot of time in prison, but a big heart—rather than crime—is to blame. The couple started volunteering with Prison Family Services in 1991, and they quickly took on more and more administrative volunteer roles. In 1992, Charles became the executive director, a title he still held in 2013, and Karma managed the money as a bookkeeper, holding seats on the board for six years, then taking one year off before starting again in 1992. The couple stay in the system to make a difference for kids who have one or more parents locked up, saying, "We want them to know there is something besides incarceration." From left to right are their son Steve, Karma, Charles, daughter Lavada Haskins, and son Glenn Brewster. (Courtesy Karma and Charles Brewster.)

Jan and Ron Wimsatt
The Wimsatts have a heart for the elderly and those in need, and they know that compassion should be at the forefront of every business. As franchise owners of Home Instead Senior Care they bring that compassion to each of their clients. Through Home Instead Senior Care, the couple also runs the Be a Santa to a Senior program and serves on various committees and organizations committed to elder care in the community. (Courtesy Home Instead Senior Care of Las Cruces.)

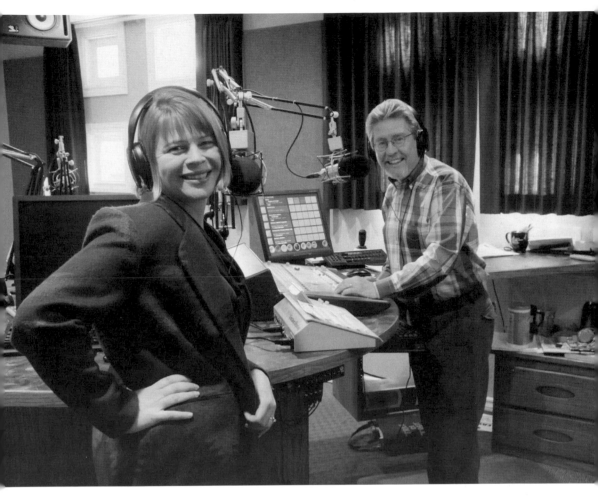

Mike McKay and KC Counts
Even those who aren't morning people make an effort to wake up to Your Morning Show on 101 Gold, which has been the number-one radio station in southern New Mexico for close to 10 years, thanks to the cheerful banter and comedic offerings from Mike McKay and KC Counts. The duo first hit the radio together on April Fool's Day in 1998 when the show was in El Paso, then became instrumental in the formation of Bravo Mic Communications, which operates three other radio stations in addition to 101 Gold. (Courtesy Bravo Mic Communications.)

Rama and Ammu Devasthali
The Devasthalis are generous, donating both time and money to worthy organizations including the Community Foundation of Southern New Mexico, NMSU Center for the Arts, NMSU's College of Arts and Sciences, the Las Cruces Symphony, Ocotillo Institute for Social Justice, and the Doña Ana Arts Council. Ammu, who has a master's degree in printmaking and a master's of fine arts in painting—both from NMSU—is an artist. Rama, a physician, is president of the Imaging Center of Las Cruces Radiology Associates. From left to right are former mayor Bill Mattiace, Ammu, and Rama. (Courtesy CFSNM.)

Tom (1933–2013) and Donna Tate

The Tates spent much of their lives traveling the world, but they found roots in Las Cruces in 1994. They made their mark as generous donors and active volunteers, with Tom serving on the MMC board of trustees and the Las Cruces Symphony Association board, and Donna serving on the MMC Foundation board (which later became the Healthcare Foundation of Southern New Mexico). The couple has two daughters, Melody and Kamella Tate.

While their philanthropy was very visible, they often preferred to be out of the spotlight, with Donna moving out of photo opportunities as soon as they arose, as she did with LCSO conductor Lonnie Klein (above, center) during an award presentation. (Above, courtesy Las Cruces Symphony Association; below, courtesy Donna Tate.)

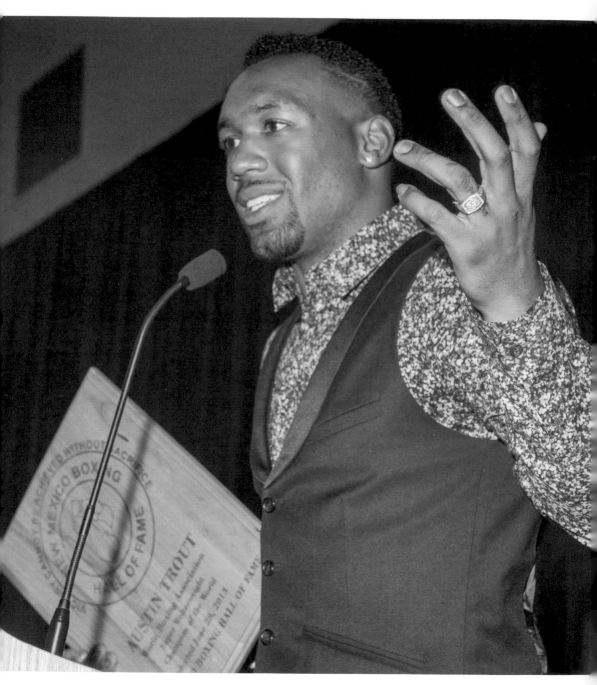

Austin Trout

Boxer Austin Trout is a local hero with a heavy fist. In 2012, he retained his WBA Super Welterweight belt with a unanimous decision over Miguel Cotto, a four-time world champion, in Madison Square Garden. More than 1.4 million viewers tuned into the event on Showtime, making it the highest-rated fight in the network's history at that time. Trout faced Saul Alvarez, who was also undefeated as a professional in 2013, going the full distance before the judges called the fight in favor of Alvarez. (Courtesy Bill Faulkner.)

Louie Burke
Burke knows what it is like on both sides of the boxing ring. Once a world-class boxer of international fame, Louie now runs the Youth Boxing Center, home to the Las Cruces Police Athletic League, a nonprofit organization that trains young boxers. He is also a world-class trainer to the likes of boxer Austin Trout. When he is not near the boxing ring, Louie serves as a fireman for the Las Cruces Fire Department. (Photograph by Russell Bamert; courtesy *Las Cruces* magazine.)

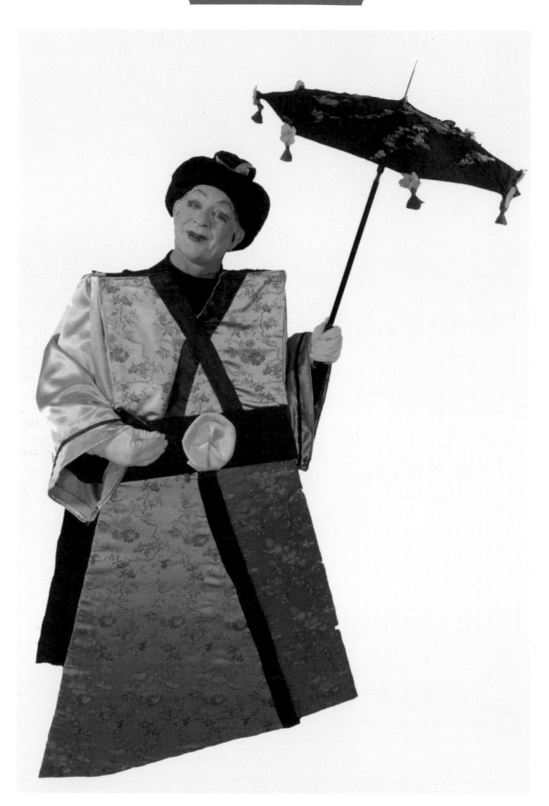

Gee 'n Ess & 'I' and George Jarden (OPPOSITE PAGE)
Gee 'n Ess & 'I' is the musical brainchild of physician George Jarden, who portrays his favorite Gilbert and Sullivan characters in a 34-role and 25-costume-change show created by Jarden. The production staff includes Brandi Lozada Johnston, choreographer; Flo Hosa Dougherty, who painted "art characterizations;" Dave Wheeler, sound and video director; and Terri Hubert, costume designer. Contributors to the original show, first presented in 2010, included David Edwards, director; Jason Stewart, computer-generated sound artist; and Rajeev Nirmalakhandan and Ben La Marca, videographers. (Courtesy George Jarden.)

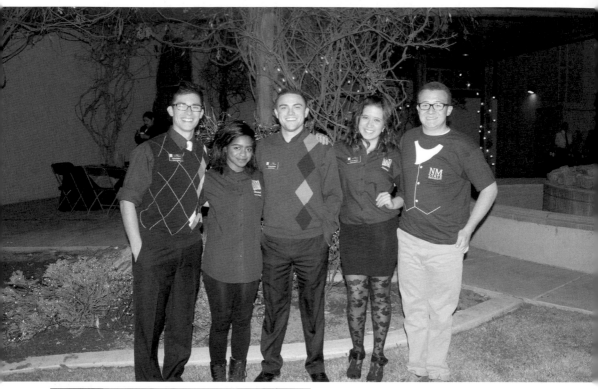

NMSU Alumni Association

As one of the oldest organizations at NMSU, the Alumni Association traces its beginning to May 24, 1898, and helps alumni and friends connect to the university through a variety of events and partnerships. The Alumni Association continues to engage, educate, and reconnect over 122,000 alumni to NMSU through the leadership of Tammie Campos, executive director; nearly 100 international board of directors members (at left from left to right: Mike Rogers of San Jose; Joel Granger of Phoenix; and Jamie Fee of Las Cruces); and the Alumni Association Executive Council, which consists of James "Lee" Golden (president), Amy Bigbee (president-elect), John Kutinac (past president), Joel Granger (secretary-treasurer), and board members Gary Beene, Steve Duran, Jack Fox, Dinah Jentgen, Nancy Ryan, Scott Sponseller, and Brandon Stewart.

The Alumni Association also provides valuable opportunities to current students. Above, Joshua Medina, Sydnie Roper, Cristian Medina, Aurora Sanchez, and Connor Pettit are pictured at the Forever Crimson event for graduating students. (Courtesy NMSU Alumni Association.)

CHAPTER FIVE

Anything Is Possible

One of the most exciting things about Las Cruces is the future. The town is full of enterprising business owners, philanthropic groups, and forward-thinking individuals. When looking toward the future, one of the main characteristics Las Crucens have is courage.

Legally blind, Letticia Martinez finds courage every time she jumps in the pool, and as she trains for the 2016 Paralympics, she is in the pool a lot. Martinez said there are times she has to mentally prepare herself, but she is constantly telling herself that she cannot be successful if she does not try. Her devotion to success has allowed her to travel the world swimming. In 2012 she participated with the US Paralympic swimming team in London, where she placed eighth in the 100-meter breaststroke and competed in the 50-meter and 100-meter freestyles, the 200-meter individual medley, and the 100-meter backstroke. Her courage is inspiring.

When Emily Calhoun returned home to work in agriculture like her dad and mom Sam and Diane did when she was growing up, she wanted to try something a little different, so she returned with the intention of growing flowers. While her flowers are a beauty in themselves, the real beauty is the fact that Calhoun is changing the face of agriculture by incorporating new technology while honoring the old ways of doing things when it comes to agriculture. As a fourth-generation farmer in the Mesilla Valley, Calhoun is passionate about finding a sustainable and conscientious alternative to share the beauty of cut flowers with the community.

Thirty-eight-year-old Marci Dickerson is a mover and a shaker who thrives both in business and philanthropy. As the owner of the Dickerson Group, which encompasses Dickerson's Catering, The Game Sports Bar and Grill, Hurricane Alley, Sports Skills Institute, and M Five, Dickerson provides hundreds of jobs within the Las Cruces community, and when she is not providing jobs, she is providing her time and money for the betterment of the city. In 2011 she was selected as the Las Cruces Chamber of Commerce Business of the Year and was appointed as a state of New Mexico tourism commissioner.

Heath Haussamen is no stranger to the community. As a journalist, Haussamen made it his mission to keep the community in the know when it came to politics. He ran the nationally recognized political news website NMPolitics.net for nearly seven years before offering his experience to start New Mexico In Depth. The 2003 graduate of NMSU never strayed from the truth, and his dedication to open government has been nationally recognized.

Garrett, Brady, and Dylan Alberson never let the fear of speed slow them down, and all three have been racing at the Southern New Mexico Speedway since they were young, following in father Craig's footsteps. Garrett began racing BMX at the age of four and continued until he was a teenager. At age 15, he started racing in the Dirt Super Truck class. He raced Dirt Super Trucks for his family-owned team for three years with his dad, mom Kathi, and family encouraging him. In 2010, he became a racer for Deetz Racing, winning the El Paso Speedway Park Late Model Championship in 2011, as well as the UMP DIRTCar Western States Championship and Championship Late Model Association (CLMA) Rookie of the Year. In 2012, he claimed the CLMA Series Championship and finished second in the UMP Western States Championship, collecting 14 feature wins along the way. The entire Alberson family knows how important it is to keep trying but to have fun doing it, and Garrett's success proves just that.

Leonard Jimenez is full of compassion and talent, and he uses both to make a difference in his life and the lives of others. He has been active in a wide variety of organizations, helping raise hundreds of thousands of dollars for the community. With a huge heart, his involvement is not limited to organizations, and he can often be found helping single mothers and others who find themselves in hard times. When he is not doing everything he can for a better community, he is traveling the world. To Jimenez, the community, and the world, is one big opportunity to be the change.

There is no limit to the success Las Cruces community members can obtain, and it seems many know that. They are reaching for the stars, and becoming stars themselves. With them, anything really is possible.

Leonard Jimenez

Jimenez can be described in many ways: artist, graphic designer, business owner, hair stylist, and philanthropist, but the characteristic he is most proud of is his passion. As co-owner of Studio 037 Salon in chic downtown Las Cruces, and a professional educator for Schwarzkopf, Jimenez travels the world learning and teaching everything he can about hair.

When he is not traveling to learn about hair, he is traveling to make a difference in the lives of others. Jimenez has worked closely with the Becky Fund, established in 2003 to aid the children of Peru; co-founded the Young Philanthropists; and raised money for the New Mexico State University DanceSport Company through Look Who's Dancing (pictured at right), where he took home the coveted crystal ball trophy. Jimenez is also credited for the success of one of the largest fundraisers in Las Cruces, the March of Dimes High Heels for High Hopes. (Courtesy Wendy Ewing and Leonard Jimenez.)

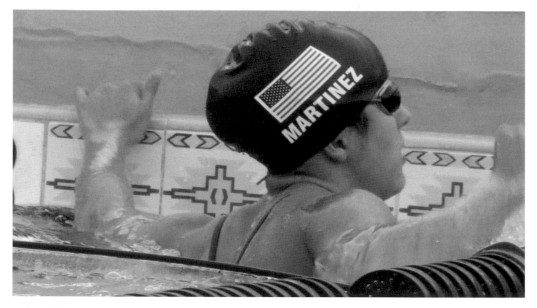

Letticia Martinez

Legally blind Martinez was diagnosed with Leber's congenital amaurosis at the age of three, but her disability did not keep her from participating with the 2012 US Paralympic Swimming Team, placing eighth in the 100-meter breaststroke. She is currently on the 2013 national team, and attends NMSU. Her experience in 2012 is helping her prepare for the 2016 Paralympics, and she is ready to win.

Martinez understands one thing that contributes to her success, and that is the fact that everyone must be ready for a challenge. (Courtesy Steve Martinez.)

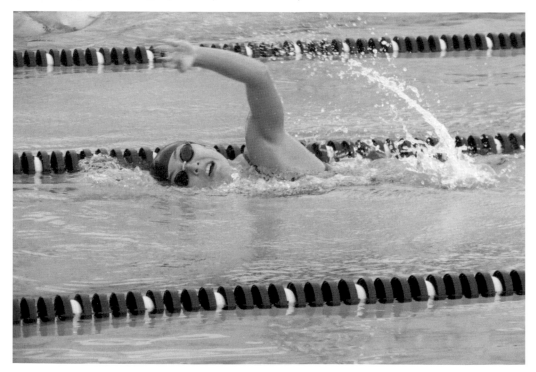

Emily Calhoun
Calhoun graduated from Southwestern University in Georgetown, Texas, with a degree in anthropology and international relations and a desire to travel around the world, but her family, including her parents Diane and Sam, had long-standing ties to agriculture and community. Now, as the owner of Floriography, a flower business she started to support agriculture in the area and build the farm-to-table initiative in the community, she is changing the way younger generations increase organic farming initiatives, sustainable agriculture, and community-supported agriculture. (Photograph by Bill Faulkner; courtesy *Las Cruces* magazine.)

Marci Dickerson

Dickerson is a mover and a shaker, and with nearly everything she does, she does it because it benefits the community in one way or another. Dickerson, owner of the Dickerson Group, which encompasses Dickerson's Catering, The Game Sports Bar and Grill, Hurricane Alley, Sports Skills Institute, and M Five, is a 1993 graduate of Las Cruces High School, 1998 graduate of Southeastern Louisiana University, and 2000 graduate of NMSU, earning her master's of business administration. Her community and business focus has people noticing Dickerson, and in 2011, she was selected as the Las Cruces Chamber of Commerce Business of the Year. In addition, she is currently a state of New Mexico tourism commissioner. (Courtesy Marci Dickerson.)

Ernie Sichler
Sichler is a native of the Rio Grande Valley, living over 20 years of his life in the Las Cruces area, and his commitment to the people and community is noticed.

In 2012, he was selected as the 2012–2013 La Mesa Lions Club Cub of the Year. He is a graduate of NMSU and has been actively involved in the Las Cruces Chamber of Commerce, Las Cruces Homebuilders Association, Big Brothers Big Sisters, and the Young Philanthropists. (Left, courtesy Ernie Sichler; below, courtesy La Mesa Lions Club.)

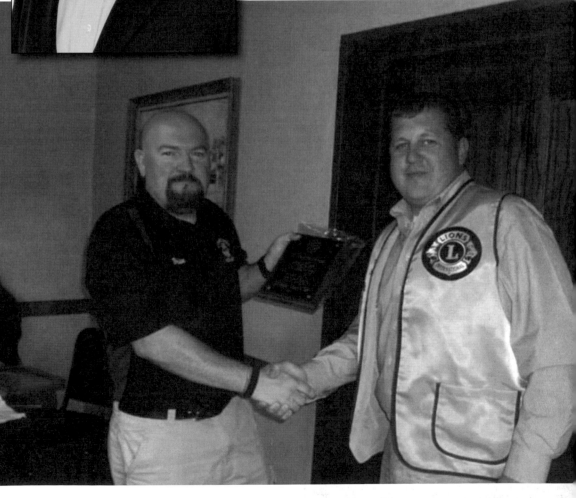

Heath Haussamen
Haussamen is a freelancer for *The New York Times* and deputy director for New Mexico In Depth, and his writing has received national recognition. In 2013, he received the New Mexico Foundation for Open Government Dixon Award. Haussamen previously ran the nationally recognized political news website NMPolitics.net for almost seven years. During that time, the Washington, DC, publication *Politico* named him one of 50 politicos across the nation "who will be a force to reckon with in the 2012 cycle," and in 2008, *The Washington Post's* Chris Cillizza named NMPolitics.net one of the best state politics blogs in the nation. He is married to Lori and the couple has one daughter, Lily. (Courtesy Heath Haussamen.)

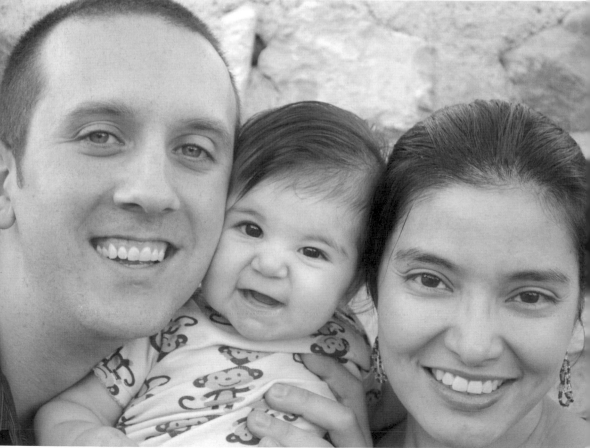

Morgan Switzer McGinley
McGinley is the current publisher of the *Real Estate Guide* and *Las Cruces* magazine. Her involvement in the community does not just show on the pages of her magazines but in the time she has volunteered to various organizations including the March of Dimes, Las Cruces Green Chamber of Commerce, and the Las Cruces Home Builders Association, just to name a few. (Courtesy Morgan Switzer McGinley.)

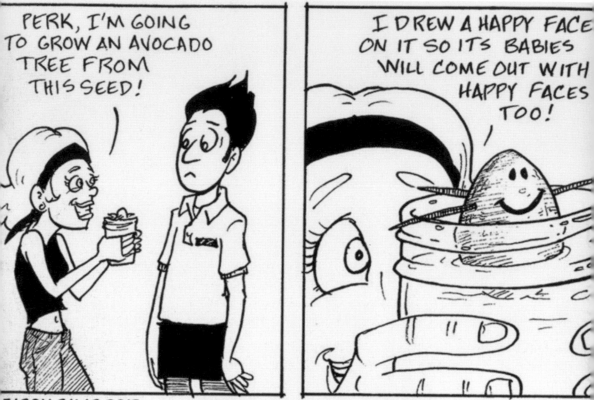

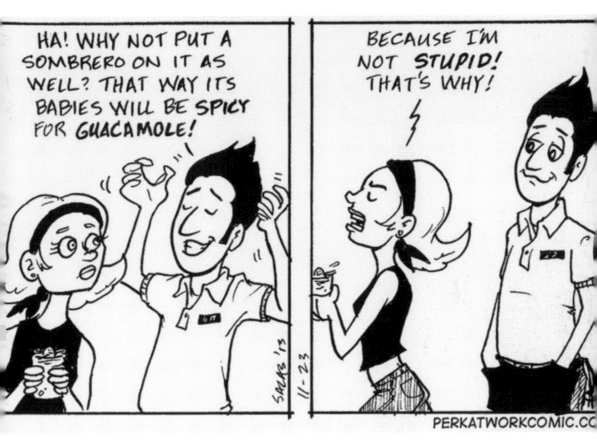

Jason Salas (ABOVE AND OPPOSITE PAGE)
Salas is a funny guy. He is the creator of the webcomic "Perk at Work," and producer of *Perk at Work Volume One: Open for Business,* and *Another Day, Another Dollar,* books that he sells at various comic conventions across the United States. His strip's main character, Perk, is a slightly nerdy cafe barista who interacts with his boss, his cook, and six regular customers who all work in the same building. In 2010, Salas worked for *MAD Magazine* during a summer internship, but the slight fame of contributing to such a cult classic did not go to his head. Salas is an avid supporter of anything that betters the world around him, and he is charitable in time, compassion, and money. (Courtesy Jason Salas.)

Garrett, Brady, and Dylan Alberson Garrett (pictured), Brady, and Dylan Alberson like to go fast. The brothers have all been involved with Team 241, starting with Garrett getting behind the super truck wheel in 2004. (Courtesy Kathi Alberson.)

La Waffle

Michel and Eva Mal know a thing or two about waffles, particularly Belgian waffles. The couple and their waffles have been featured on the Food Network and the Travel Channel, but the brightest spotlight on them is at the Las Cruces Farmers Market every Saturday when they sell their golden, luscious waffles from their food truck. (Courtesy Lincoln Michaud.)

Carlos Parra

As a self-proclaimed professional geek and owner of CarlosParra.com, Parra is a web developer, designer, SEO expert, blogger, programmer, and Internet marketer. His experience did not come from a specialized education, but from a desire to learn what the community needs and then to give it to them. The focus on community does not just have to do with businesses—when he realized the community wanted more zombies, he formed Sleeping Awake Productions and then wrote and directed *Dark New World*. Pictured below, Parra takes a break with Patrick J. Waggaman, playing Thomas Gunn, while filming *Dark New World*. Carlos is married to Heather and the couple has one son, CJ, who secretly believes he is Spider-Man. (Courtesy Carlos Parra.)

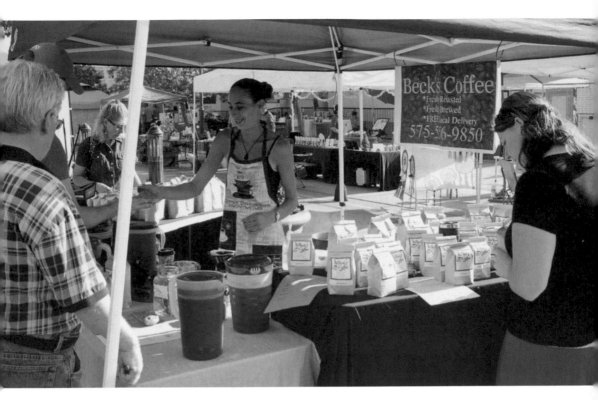

Beck's Coffee

Beck's Coffee was founded in 2010 by Rebecca "Beck" Rosnick when she began roasting coffee beans in her home. Now her coffee can be found every Wednesday and Saturday at the Las Cruces Farmers Market, but her special blends are enjoyed all over town. (Courtesy Lincoln Michaud.)

Wendy Ewing
Ewing has an eternal talent. As a photographer and owner of Studio E Photography, she captures families, friends, and faces in time, allowing memories to stay in full color forever. She is an avid community supporter and has devoted time, money, and resources to a variety of organizations. (Courtesy Wendy Ewing.)

Kelly Allen

Allen opened Amaro Winery in the downtown area of Las Cruces in 2009. The old building retained its historic appeal, and Allen added a contemporary, urban feel. Production of Amaro's red, white, and dessert wines is done in a separate building a few steps from the wine bar. Pictured here are Shawn, Kelly, and Hayden Allen. (Courtesy Kelly Allen.)

Amanda López Askin

Askin is the host of *Prescription for Health* on KSNM 570, and her devotion to the well being of both pets and people is apparent in everything she does. She has been a school mental health advocate for the New Mexico Department of Health for eight years. She has provided a foster home for numerous animals, including those who must heartbreakingly be left behind by deployed military men and women, and when she cannot foster, she finds someone who will. She is an active community advocate, shown elaborately dressed for one of the many fundraisers she participates in. (Courtesy Amanda López Askin.)

Unified Prevention! Coalition (ABOVE AND OPPOSITE PAGE)
United Prevention Coalition, also known as UP!, is a collaboration of community-minded individuals, private and public non-profit agencies, and government officials determined to end the cycle of alcohol and drug abuse among area youth, led by chair Michelle Ugalde.

In 2012, former coalition coordinator Stephanie Armitage accepted a check from the Elks Lodge No. 1119 board of trustees member Kim Hayes to help fund the annual prom party at the movie theater, held as an alternative to drinking. (Courtesy CFSNM.)

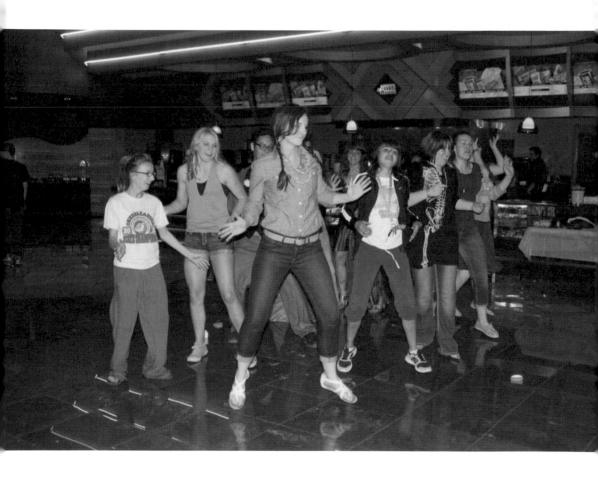

Sir Richard Branson (OPPOSITE PAGE)
Branson owns the world's first commercial passenger spaceline company, Virgin Galactic at Spaceport America, located 55 miles north of Las Cruces. Spaceport America will host private enterprises, and is intended to be the launch pad of the global commercial spaceflight industry and the second space age. In 2008, Virgin Galactic signed a 20-year lease agreement with the New Mexico government, establishing its operations at Spaceport America. On April 3, 2007, Doña Ana County voters passed a spaceport tax referendum providing $49 million of the $209 million construction funding for Spaceport America. Las Cruces area partners with Spaceport America include The Las Cruces Convention and Visitors Bureau, Mesilla Valley Economic Development Alliance, and White Sands Missile Range. Branson, who has proven he might be good at making money but not at taking life too seriously, joined an aerial ballet group that flew across the glass edifice of the terminal building at Spaceport America during the grand opening in 2011. Hanging on a rope attached high on the structure, he sipped on champagne and announced the structure was named the Virgin Galactic Gateway to Space. (Courtesy Bill Faulkner.)

Dr. Patricia (Pat) Hynes
Hynes has served as director of the New Mexico Space Grant
Consortium since 1998, and in 2007, she was appointed director
of NASA's Experimental Program to Stimulate Competitive
Research. Both programs under her leadership are headquartered
at NMSU. (Courtesy Bill Faulkner.)